MW01054837

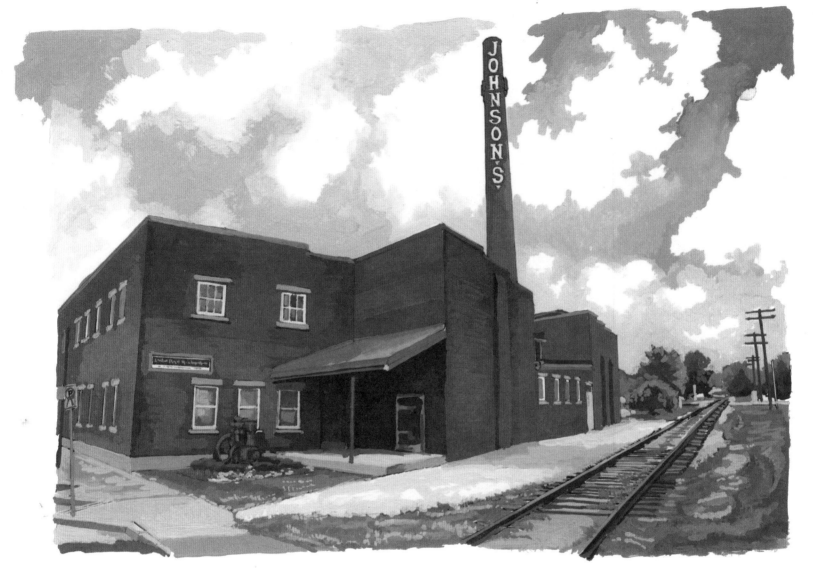

# Bloomington Chamber of Commerce

*Serving as the 'voice of business' in Bloomington and beyond, this compelling vibrant organization has taken a progressive stance in fostering growth and development through action, service, and advocacy.*

For more than eighty-nine years, The Greater Bloomington Chamber of Commerce has had a dynamic presence throughout southern Indiana.

Occupying a renovated suite of offices in the famed Johnson's Creamery, circa 1913, the Chamber has, in many ways, assumed the responsibility of nourishing the community by serving as a regional resource that is categorically and unconditionally committed to nurturing and revitalizing the city of Bloomington and the region beyond.

Initially established in 1915, the Chamber now has a flourishing membership of over 1,000 area for-profit and nonprofit businesses and individuals. While some of the region's largest corporations and employers, including General Electric, Indiana University, Cook, Inc., PTS, and Bloomington Hospital and Healthcare System, reap the plentiful rewards of involvement in Chamber-sponsored programs and activities, membership in the Greater Bloomington Chamber of Commerce—like in most Chambers nationwide—is primarily comprised of small businesses.

According to Steve Howard, a retired Navy Captain officer who became president of the Chamber in 1994, ninety-three percent of the organization's members employ one hundred or less employees. Of that figure, sixty percent have ten or fewer employees and forty-one percent have no more than five employees.

The Chamber caters to its core membership of small businesses by targeting its three principal mission objectives—service to members, community investment, and effective advocacy.

Fostering business and community growth and development is a fundamental aspect of the Chamber's service. One special program of the Chamber is the South Central Indiana Small Business Development Center (SBDC), a regional organization that provides resources and counseling to both start-up and established businesses, and hosts training and education seminars, generates and distributes research and market information, and maintains an open-door policy for its members and others who call on the Chamber for its business expertise and assistance.

Offering exclusive discounts is another example of the Chamber's service to its members.

Recognizing that health insurance coverage is often a key concern for small businesses, the Chamber has partnered with the Southeastern Indiana Health Organization (SIHO) to offer a variety of affordable plans and products for members employing between two and fifty individuals. The Chamber also maintains an affiliation with

WBWB/WHCC, a local radio station, which produces and broadcasts free "Chamber Minute" radio spots in order to collectively and individually promote the Chamber and its members.

Based on the rationale that a healthy community attracts businesses that will, in turn, make vital investments critical to continued growth, the Chamber generously invests in the community as part of its service mission. The Chamber has had, for example, a profound influence in Bloomington's educational community by sponsoring innovative programs that cultivate alliances between area schools and businesses, while helping students make judicious career and lifestyle decisions.

Within the past decade, The Franklin Initiative, the community's "school-to-career program," has developed an array of educational programs in local schools that provide real-world connections for students. Of special interest is the Reality Store, a program in which middle school students are given fictional salaries, based on their GPAs, that are used to "shop" for homes, automobiles, and other services. The highly successful program

*"The fundamental goal of the Greater Bloomington Chamber of Commerce is to promote growth and development in business and throughout the community. When business is strong, the community is strong."*

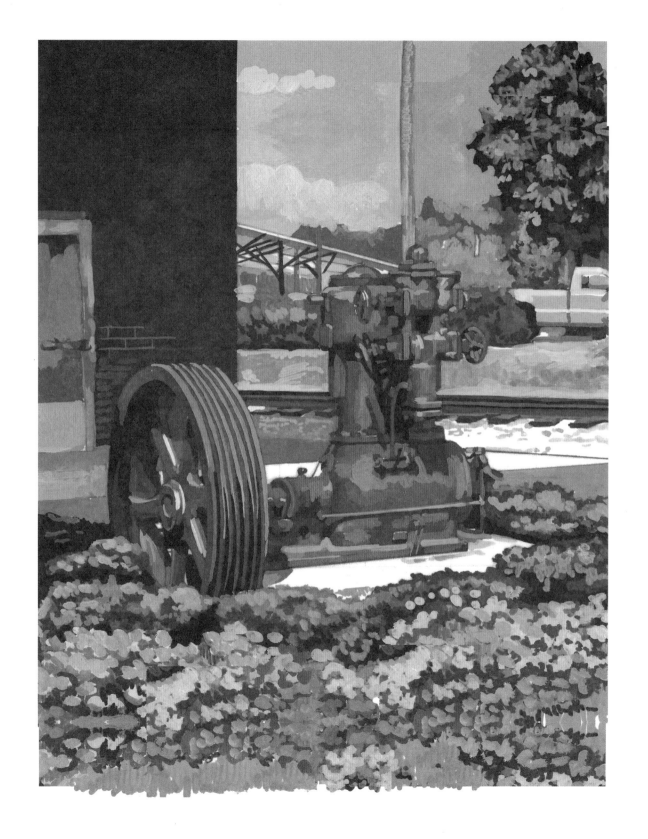

teaches adolescents the importance of budgeting and the relationship between success in school and in later life.

"Our continuing involvement in education," Howard says, "is a reflection of the long-term investment the Chamber has made in Bloomington. Kids are, after all, the "seed corn" of every community."

First and foremost, however, the main value the Chamber provides to its members—and one of its most important objectives—is its role as the "voice of business." Serving as an advocate "for all businesses," the Chamber represents their business interests on the local, state, and federal level by strategically addressing a variety of issues, including zoning, infrastructure investments, and planning, among others.

On record as Monroe County's "oldest and largest advocacy organization," the Chamber identifies numerous specific issues of concern every three years, which are published in a comprehensive report called "Community Vision" that serves as the foundation for all of the Chamber's ensuing efforts.

In addition, the Chamber identifies a yearly "High Five," an "intensive-care list" of five short-term core programs or community initiatives, as its action priorities for the coming year.

Providing opportunities for socializing and networking is an important component of the Chamber's effort. In addition to organizing an annual golf outing and monthly Business After Hours functions, the Chamber

holds an annual meeting that, boasts Howard, "fills the Bloomington Convention Center to capacity with over six hundred members and guests." Highlights of the event include the inauguration installation of the new board of directors and the presentation of awards to selected members and community leaders.

Each year the Chamber and SBDC also hold a Business EXPO, the largest business-to-business trade show in Southern Indiana. EXPO features 150 booths and attracts approximately 5,000 attendees.

Ongoing media exposure keeps the Chamber and its work in the public eye. Each week, for example, Howard records "Bloomington Business," a thirty-minute radio show highlighting issues important to small businesses that airs every Saturday at 12:05 p.m. and Sunday at 10:05 a.m. on WGCL AM 1370. Chamber "Chats" are held every Tuesday morning at 7:30 at the Village Deli on Kirkwood Avenue, featuring speakers from the community and region to discuss topics of interest to local business.

The Chamber also co-sponsors "Third House: The People's Voice" with local television station WTIU, which provides a forum for state legislators to discuss the issues during the legislative session. In addition to an impressive presence on the internet (www.chamber.bloomington.in.us) and a monthly newsmagazine, *Business Network*, the Chamber publishes an annual business directory, offering free listings to all members. The publication's cover design is selected from en-

tries submitted in a Chamber-sponsored art contest, an innovative idea that exemplifies the Chamber's role in fostering alliances within Bloomington's art and business communities.

"A good community, like Bloomington, is made up of many elements," Howard says. "Most of the wealth within a community, however, comes from the business sector, through employment, capital investments, and taxes. Even local social services organizations and the arts are supported by business.

"The fundamental goal of The Greater Bloomington Chamber of Commerce is to promote growth and development in business and throughout the community," Howard concludes. "When business is strong, the community is strong."

THE CHAMBER
THE GREATER BLOOMINGTON
CHAMBER OF COMMERCE
P.O. BOX 1302, BLOOMINGTON, IN 47402-1302
812/336-6381 Facsimile 812/336-0651
WEB: www.chamber.bloomington.in.us
E-MAIL: info@chamber.bloomington.in.us

*The Greater Bloomington Chamber of Commerce is located in the historic Johnson's Creamery at 400 West Seventh Street, Suite 102, in Bloomington, Indiana. For more information, call the Chamber at 812-336-6381, or visit www.chamber.bloomington.in.us.*

# Bloomington Sketchbook

Paintings by Local Artists • Uniquely Bloomington by Douglas S. Wissing

Indigo Custom Publishing

| Publisher | Henry S. Beers |
| Editor-in-Chief | Martha Elrod |
| Art Director/Designer | Jennifer Shermer Pack |
| Operations Manager | Gary Pulliam |
| Associate Publisher | Richard Hutto |

Cover Art: top, Jane Jenson;
bottom row from left to right, Betty C. Boyle, Suzanna Hendrix, Elizabeth Sturgeon, Cathy Korinek, and Jane Jenson.

Printed in Hong Kong

Library of Congress Control Number: 2004113631

ISBN:  0-9725951-5-5

Indigo custom books are available at quantity discounts
with bulk purchase for educational, business, or sales promotional use.
For information, please write to:
Indigo Custom Publishing, 3920 Ridge Avenue, Macon, GA 31210,  or call 866-311-9578.

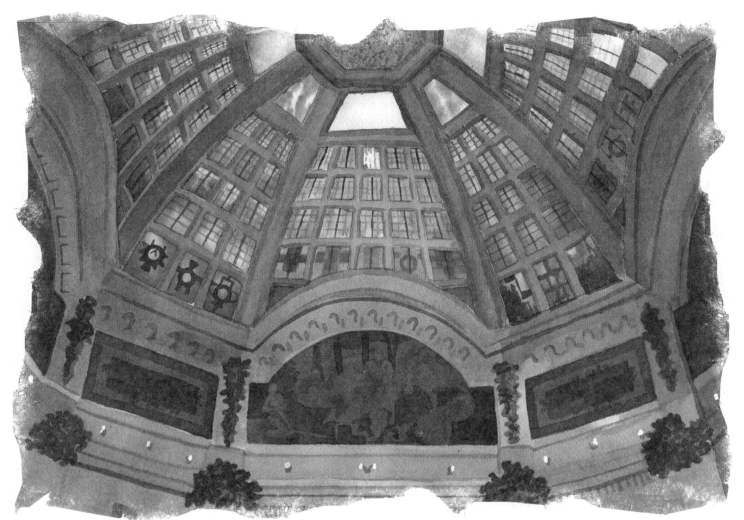

# Bloomington Sketchbook

Paintings by Local Artists • Uniquely Bloomington by Douglas S. Wissing

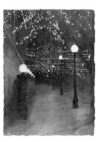
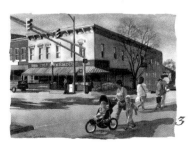

3

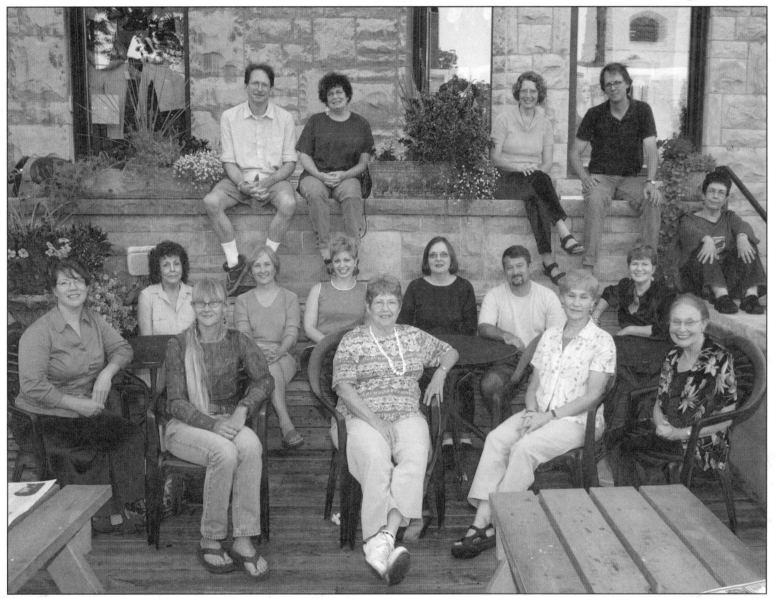

Photo by Stillframes Photography

Back row, left to right, Tom Rhea, Jodie Estell, Paula Bates, Tim Kennedy; Middle row, left to right, Sammye Smith, Trisha Heiser Wente, Suzanna Hendrix, Cathy Korinek, Don Madvig, Shelley Frederick, Linda Meyer Wright; Front row, left to right, Elizabeth Sturgeon, Cheryl Duckworth, Jane Jenson, Jackie Frey, Connie Brorson; not pictured, Betty C. Boyle, Michael Cagle, Jeanne Iler, Mary Jo Limp, Drummond Mansfield, Robin Ripley, Bridgette Z. Savage

# Introduction

A watercolor painting seems to me the perfect medium to depict Bloomington, watercolors being a hazy semi-aquatic art form that blurs the edges and brushes the truth into gauzy impressionistic packages. It matches the dreamy view that many people still have of Bloomington.

Many who remember the Bloomington of forty years ago note the many changes since that time. The courthouse square doesn't close on Wednesday afternoons anymore. Prosperous neighborhoods with mature trees stand where there were farm fields, and commercial energy bustles where the town used to bleed into hill country. Culture leapt over the university's limestone fence many years ago and roams the town. On those crisp fall nights when thousands flock to Bloomington to hear musicians of a thousand stripes, it is clear something extraordinary happened to this little Indiana town.

Some things remain the same, however. With migratory reliability, the university students return each fall. And sometimes English isn't the only language you hear, but now the students represent 123 different countries— from Azerbaijan to Zimbabwe. Little 500 bicycle riders continue to fuel their training runs with dreams of breaking away, and whiffs of peppery fried chicken still waft from Hoosier cafés. Music streams from university recital rooms and thumps of basketballs can be heard in driveways and practice gyms all over town. Couples still kiss at the Well House and the people in Bloomington are still very friendly. The postal clerk knows customers by name, and the shoe repairman offers fishing tips. The public library clerk is delighted when patrons discover her favorites. Mothers watch out for each other's children, and the guys at the muffler shop will try to patch it together for that Christmas trip home. It's a good town.

*Welcome to Bloomington, Indiana.*

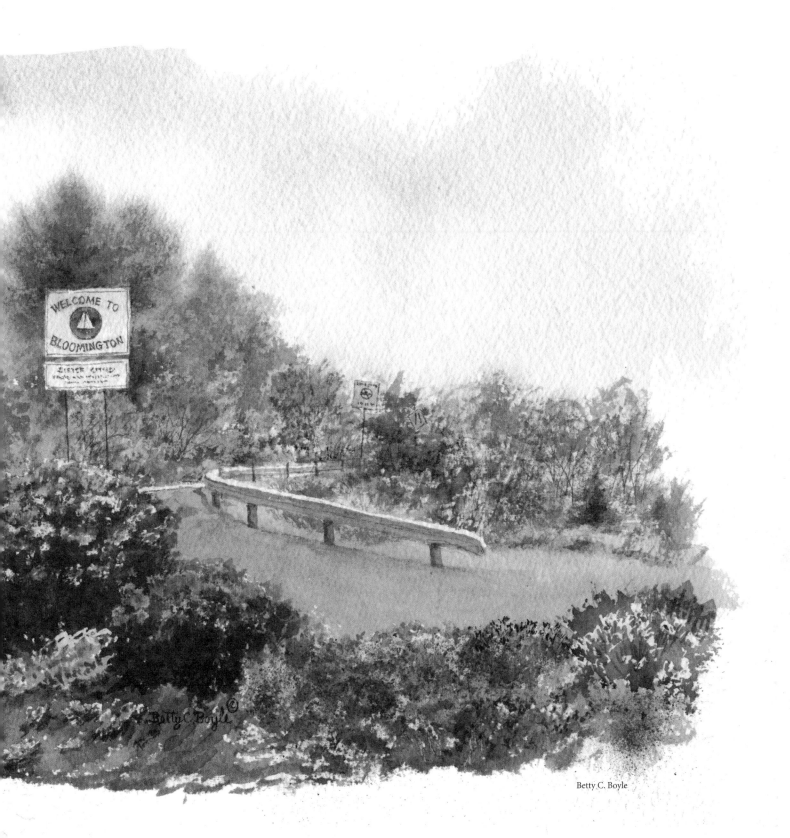

Betty C. Boyle

7

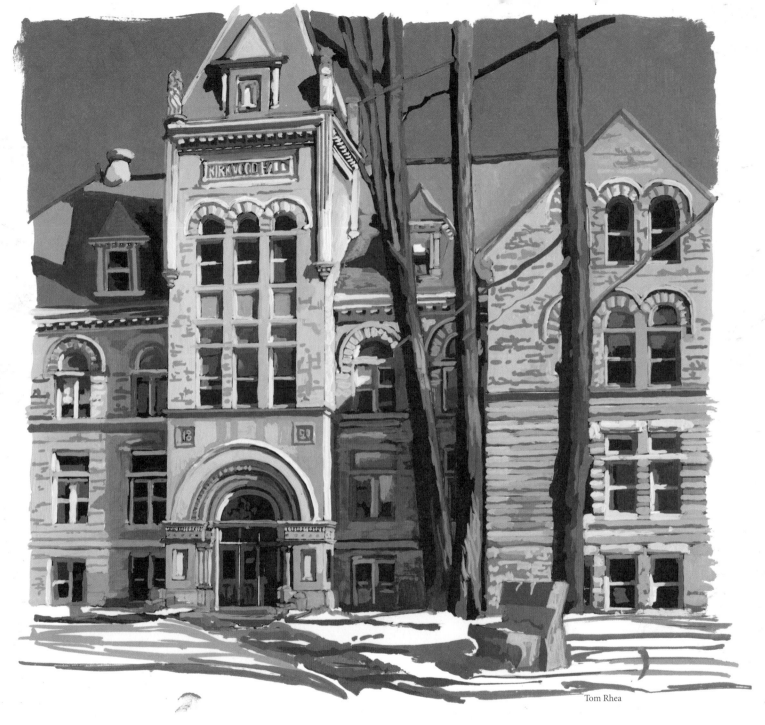

Tom Rhea

*Kirkwood Hall celebrated its centennial in 2000. Built under the presidency of Joseph Swain (1893–1903), this hall and a nearby observatory were named after Daniel Kirkwood, 19th-century astronomer.*

# History of Bloomington

The original settlers named the place for the wild profusions of flowering trees they found blooming on the rugged hillsides. They began drifting into the high limestone ground between the two forks of the White River in 1815. Three years later, Bloomington became the county seat for the newly organized Monroe County.

The university soon followed. In early 1820 the Indiana General Assembly and Governor Jonathon Jennings selected Bloomington as the site of the state seminary. In an act of gubernatorial larceny, Jennings arranged for the federal land grant previously assigned to the college at Vincennes to be diverted to Bloomington, precipitating both the founding of Indiana University and the legal warfare that lasted for almost a century. When the fledgling Indiana Seminary (soon to be Indiana College) opened five years later, Bloomington was a tiny town of three hundred.

The remote college boasted a red-bricked building modeled on Princeton's Nassau Hall, a professor's home for its only teacher, and ten young men with a passion for learning. Initially, Professor Baynard R. Hall taught only Latin and Greek, as these were his strong subjects. The professor soon organized his students into a literary society. In the spirit of classicism, each of the backwoods scholars took a Greek or Roman name, proceeding through their academic lives with names such as Ajax, Pericles, or Timolean.

Both the town and college stumbled along for the next several decades. When the student body ballooned into triple figures in 1838, the state assembly re-chartered the seminary with the august title of Indiana University.

The New Albany and Salem Railroad (later the Monon) arrived in 1854 to augment the bumpy stage route. In the post Civil War anticipation of growth, the legislature began appropriating state funds for the university and during this same period, the school first admitted women.

By the 1880s the growth of Bloomington began to be apparent. While IU continued its progress at the campus adjacent to the railroad at Second and College, the budding limestone industry wrenched fine Oolitic limestone from local pits to sell in Chicago and in the Eastern cities. The Showers Brothers exploited the abundant local forests for their growing furniture factory. Local circus entrepreneur H.B. Gentry dispatched his renowned dog and pony show across the country, returning to winter quarters on south Rogers.

Fires in 1883 and 1884 changed the town's landscape, however, both physically and culturally. On July 13, 1883, a lightning strike ignited a fire that swept through the three-story IU classroom building, destroying the entire university library, collections, and scientific equipment. The town responded with broad, enthusiastic support with Monroe County pledging fifty thousand dollars for rebuilding. The Board of Trustees determined to move the campus to a new site. They bought twenty acres of Dunn's Woods east of the square, and broke ground on Wylie, Owen, and Maxwell halls the next year. Student rooming houses clustered around the new campus, followed by gracious homes for faculty and professionals. That same year the eastside Showers Brothers' factory at Ninth and Grant burned to the ground. In a kind of town teeter-totter, the Showers decided to rebuild beside the rails on west Morton, which became the anchor of the westside working-class neighborhood.

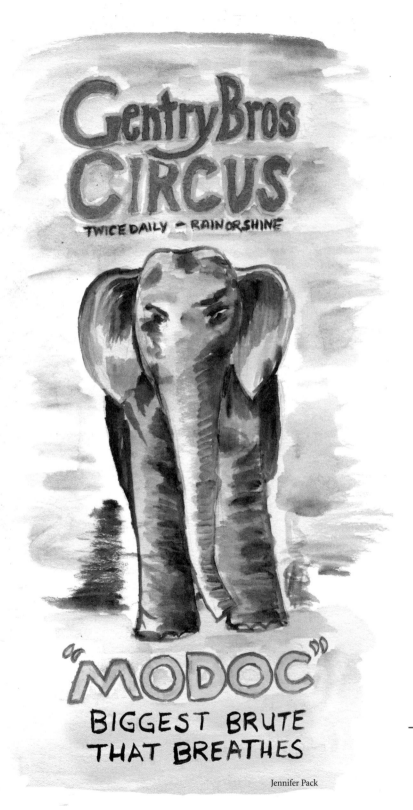

Gentry Bros
CIRCUS
TWICE DAILY ~ RAIN OR SHINE

"MODOC"
BIGGEST BRUTE
THAT BREATHES

Jennifer Pack

By the 1920s dozens of local limestone quarries and mills employed over two thousand stonecutters. With distinctive saw-toothed roofs, the Showers Brothers furniture factory eventually sprawled to a dozen buildings on seventy acres that employed 1,500 workers—the country's largest furniture factory. H.B. Gentry's circus empire boomed in the early twentieth century. In 1910, Gentry had four different shows, with 170 circus people criss-crossing America on fourteen double-length railroad cars. At various times, the troupe included twenty-two elephants, twelve camels, monkeys, a hundred trick ponies, fifty large horses, performing razorback hogs, "educated" Persian sheep, a multitude of well-trained dogs, and two bands of forty musicians reputed to be the best in the region.

And Gentry was just one of Bloomington's traveling shows. Howard's Ponies roamed the nation with his equine performers. The Shipp and Feltus Circus toured South America. Rivaling Buffalo Bill's Wild West Show, local showman Robert Harris toured nationally with his "Daniel Boone and Trail" production that included Nebraska Sioux led by Bounding Elk, who fought at Little Big Horn.

For most of the circus people, Bloomington was home. In 1915 the local *Daily Telephone* wrote, "Probably no other city of its size in the United States can boast so substantial a colony of show people as Bloomington's and one that has at all times been loyal in every way to its home town." Like many of the circus people, Gentry invested his money in Bloomington. He owned substantial amounts of real estate, including the southwest corner of the square, the biggest hotel in town, and his south Rogers

*In the early 1900s, the Gentry Brothers Circus advertised their shows with illustrated posters similar to this one.*

farm. Robert Harris developed a block of north Walnut with two grand theaters. Circus executive W.W. Durand built the Monroe County States Bank Building. Circus workers wintered in cottages on the west side, often keeping the livestock in tiny backyard barns.

The university weathered a perilous period around 1910, when state officials made yet another threat to remove it lock, stock, and barrel to Indianapolis. Carrying a suitcase full of money, H.B. Gentry led a group of town leaders to a meeting with the governor. When the meeting was over, the decision was made to keep the university in Bloomington.

A concoction of free spirits, flapper skirts, bootleg whiskey, and jazz was rampant on the Roaring Twenties campus. A couple of gregarious young Hoosiers, Hoagy Carmichael and Herman Wells, led the raucous activities. Carmichael was a Bloomington boy, who grew up within walking distance of the university. In the ferment of the twenties, Carmichael discovered the jazz music that leaked out of New Orleans and spread up the rivers to the Midwest. Jazz great Bix Beiderbecke and the Wolverines played IU fraternity parties and Hoagy Carmichael jammed at the Book Nook (now the Gables) across from campus. His musical ensemble included a wild retinue of surrealists who spouted nonsense poetry and held satirical commencements on Indiana Avenue. Among those who took part in the graduation was a popular young economics lecturer named Herman Wells. Wells wrote, "Many highly individualistic characters were drawn to the university from other, less hospitable places and they contributed an effervescent quality to the student life. With companions like these life was never humdrum."

By the twenties, Bloomington's artistic life was also alight. Nationally renowned painters such as C. Curry Bohm, Marie Goth, V.J. Carriani, Carl Graf, and Adolph R.Shulz exhibited at IU, as did T.C. Steele, the dean of the Brown County School. Steele began his relationship with IU in 1898 when he sold paintings to the university. In 1907 he wrote in his diary from a temporary studio in the Student Building that overlooked Dunn Meadow:

"The view from the studio was magnificent. A beautiful green meadow, a great plain of sunlit green, dotted here and there with children playing. Houses beyond it and a great sky of silver clouds. A beautiful stream runs through it."

Steele became a familiar figure on campus, a tall man in a fedora, intent on the canvas before him. In 1916 the university awarded him a Doctor of Laws and named him Honorary Professor of Painting in 1922. Steele established a much-visited studio in the university library attic at Kirkwood and Indiana. He sold a large collection to the university in 1923, which still graces the campus. When Steele died in 1926, the university officially mourned his death by canceling classes.

Herman Wells was destined to lead Indiana University into the world-class status it holds today. When he assumed the presidency in 1937, however, Bloomington was mired in the depression. Orders for the stone industry and for Showers Brothers' furniture had plummeted. The circus business was dead, but didn't yet know it. The university was the one bright and vital spot in town, as generous New Deal federal grants and programs funded grandiose construction projects, such as the Student Union and the IU Auditorium. With job prospects dim, many Hoosiers chose to ride out the depression as students. By the beginning of Wells' administration, there

were over 12,000 students on campus, the thirteenth largest university in the country.

A tidal wave of government-funded students arrived on campus after serving in World War II. Between 1943 and 1947 enrollment grew by 300%, and overwhelmed the available facilities. Hundreds of little house trailers were installed just south of Seventeenth Street. Hoosier Courts, a formation of wooden army barracks for GI-Bill married housing, stood north of Tenth Street. By 1948 there were 2,100 IU employees, triple the number in 1940. For the first time, the university was a dominant economic player in Bloomington. The town began to look less like another Indiana county seat than a homespun version of a New England college town.

Spirits soared in February 1940 when the Radio Corporation of America announced its purchase of one of the Showers Brothers' buildings so it could build radios, adding modern industrial products to the old low-tech limestone and furniture businesses. By 1942 RCA employed 1,200 workers, most of whom were young women. In 1949 the company manufactured its first television set, and within five years employed 3,000 people. A sprawling new RCA television plant opened in 1953 on south Rogers at the old Gentry winters quarters. Sarkes Tarzian's tuner factory on Hillside Drive soon prompted Bloomington to promote itself as the Television Capital of the World.

The town square was bustling with the Graham Hotel, Wicks Department Store, five-and-dimes, hardware stores, the Faris Brothers' market, and numerous professional offices. Trains from Chicago and the south steamed into the terminal a block west of the square, near the "levee," the raffish block of west Kirkwood that was crowded with taverns, grocers, and second-hand stores.

On August 20, 1953, one Bloomington story dominated the nation's media, pushing aside Senator McCarthy, the Korean War, the Rosenbergs' execution, and even the Russian's first H-bomb. It was the publication of IU professor Dr. Alfred Kinsey's Sexual Behavior in the Female Human. The dry academic study was a popular bombshell, similar to war coverage or a presidential assassination. Almost eighty percent of the nation's newspapers ran the story, many with banner headlines. Among the dozens of magazines that reported on the publication, Time pictured Kinsey on the cover and ran a six-page story. Life printed twelve pages on Kinsey, and Cosmopolitan wrote, "Well, the Kinsey report on female sexual life—the most feverishly awaited, most widely speculated on, most sensationally publicized book in history—is open for inspection at last."

Journalists arrived in droves in attempts to unveil lurid tales. Kinsey became a literary phenomenon and phrases such as "Kinseyish" and "Kinseyesque" entered everyday jargon. Around the country, Bloomington was gaining notoriety.

Baby boomers started arriving on campus in the mid-1960s as the war in Vietnam heated up and vast social changes roiled the nation. IU's enrollment had jumped to 26,000 in 1967, up by forty percent from 1960. Monroe Lake was completed in 1964 and helped solve the perennial water shortage that had stifled Bloomington's growth. About the same time, RCA workers began a series of strikes. Bill Cook, a young medical products salesman from Chicago, began crafting medical instruments with the help of his wife, Gayle, in their eastside apartment's spare bedroom.

A roller-coaster ride of cultural upheaval and more

boom times had begun. Emboldened by the fervor of the Civil Rights and Free Speech movements, students held the first meeting of the radical left-wing Students for Democratic Society (SDS) in the fall of 1965. Two years later, an alphabet soup of student activist organizations planned their participation in a variety of causes, ranging from opposition to the Vietnam War, racial intolerance, and gender discrimination to emerging environmental concerns and outrage over tuition hikes. An exotic mixture of small businesses such as The Other Side record store and the Go for Baroque head shop sprang up along Kirkwood. A small shop called The Gallery opened in 1968 on Grant Street, which sold artwork by IU art professors. The Black Market at Kirkwood and Dunn (People's Park today) purveyed African and Black Liberation merchandise—until the Ku Klux Klan firebombed the store the day after Christmas in 1968.

The political turmoil culminated in 1969 when protests against a sixty-seven percent tuition increase erupted into a massive student strike. On May Day more than 3,000 students rallied in front of Owen Hall chanting, "All strike, shut it down." The next day a fire broke out in the university library in Franklin Hall, which was later found to have been started by a disgruntled library employee. As smoke billowed from the windows, a somber crowd of onlookers watched from Dunn Meadow. In a fashion that became the norm for Bloomington, activists held a benefit dance to replace the burned books. Entertainment and activism have become inextricably entwined in the decades since.

While still tumultuous, political activism in Bloomington was considerably more placid than hotbeds such as Berkeley and Madison. During the 1970s and 1980s,

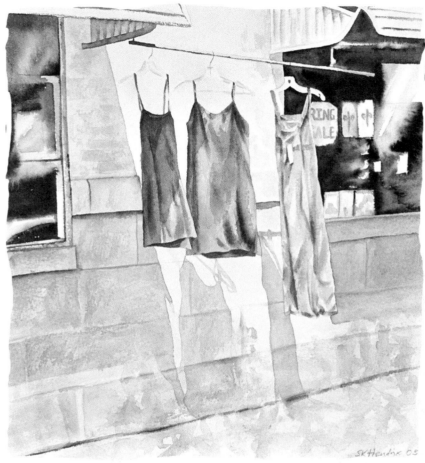

Suzanna Hendrix

*A walk down Kirkwood Avenue is an adventure for the senses. Textures, colors, smells, and sounds abound with the interesting shops, theatres, foods, and, of course, people. Here a trio of party dresses dance in the breeze outside a clothing store.*

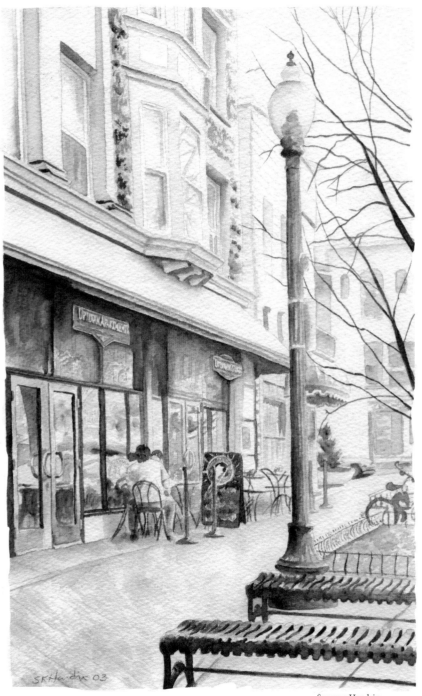

SK Hendrix 03

Suzanna Hendrix

counter-cultural music and art, liberal politics, and a healthy economy gave small-town Bloomington a kind of merry pirate persona in conservative Indiana. The change in voter age in 1971 gave Indiana University students the vote for the first time and Mayor Frank McCloskey an eight-year regime, the first of Bloomington's liberal democratic administrations.

The Showers Brothers' factory closed in the 1950s, but RCA and other industries on the west side, including Otis Elevator, GE, and Westinghouse, were in high production. Bill and Gayle Cook's bedroom catheter business had rapidly grown into an expansive complex on Curry Pike, on its way to internation status with Cook's motto, "Ready, Fire, Aim." In spite of constant funding battles with the state legislature, the university continued its growth. The opening of College Mall in 1965 helped create or cause suburban development on the east side.

As romantics attracted to the thriving counter-cultural town began small businesses, the town saw a surge of entrepreneurial zeal. Three liberal arts graduates trying to hang around began Sunrise Publications in a garage on Allen Street in 1974. Now owned by Hallmark, Sunrise/InterArt is a leading national player in printed social expressions and employs several hundred workers. John and Judith Rose started weaving on a table loom

*A favorite lunch spot for students and downtown business people is the Uptown Café on Kirkwood Ave.*

in their log-cabin dining room before opening Textillery Weavers in 1976, evolving into a leading national producer of hand-woven decorative items. Before leaving in the early 1980s, the Rudrananda Ashram parlayed an urban sensibility with devotees' labor to launch a number of successful businesses that included the Tao Restaurant (now Yogi's) and the Vienna Dog House (now Village Deli), bringing hip cuisine to a meat-and-potatoes town. Michael Cassady began his Uptown Café in a tiny storefront on Walnut.

International musicians such as Menahem Pressler, Janos Starker, Joshua Bell, Eleanor Fell, David Baker, John Mellencamp, and Kenny Aronoff made Bloomington their home, as did artists such as Rudy Pozatti, Robert Barnes, George Rickey, and James McGarrell. Dozens of potters, painters, sculptors, jewelers, photographers, musicians, and writers helped sustain a tier of creative industries that included recording studios, music stores, art presses, and graphic arts businesses.

The 1979 movie *Breaking Away* immortalized Bloomington as a leafy refuge for idiosyncratic personal growth. The creative excitement contributed to both the town's financial expansion and reputation as a cultural haven. Bloomington had become the fastest growing city in Indiana.

As the 1980s arrived, architectural preservation and transformation became an increasingly debated issue. Led by Rosemary Miller and Gayle Cook, preservationists in 1980 reinvented the old Carnegie Library as the Monroe County Historical Museum. Four years later a "Save the Courthouse" campaign restored the Beaux Arts splendor of the 1908 Monroe County Courthouse, igniting an interest in renewing the downtown square. Bill and Gayle Cook also spearheaded private preservation initiatives,

restoring the Graham Hotel in 1979. Massive renovations of structures on the south and west side of the square would follow over the next several years. In time, private developers restored many buildings in the downtown area and Bloomington was being reborn into an economically vital destination.

With the 1992 transformation of the old City Hall into the John Waldron Arts Center, arts activists added cultural vibrancy to the mix. Two years later the grassroots-organized Lotus World Music and Arts Festival unleashed its cross-cultural celebration. Directed by impresario Lee Williams, the festival quickly leapt into the A level of world-music festivals around the country.

At the turn of the twenty-first century, Bloomington sits at the crossroads between preservation and transformation. The question of a new interstate splits the town into opposing camps. As New Urbanism precepts take hold and upscale housing is being built in the downtown area, tall apartment buildings are being built that previously would have been considered gauche in their immensity. The old west side neighborhoods are being reborn as charming cottages and bungalows attract an eclectic mix of working people, professionals, artists, retirees, and IU community members.

Bloomington's cultural life remains as lively as ever, but some don't welcome growth. The university continues to grow, but Indianapolis claims an increasing share of the state's educational resources. Generation Xer's are beginning to return to raise their children, but worry there won't be jobs for them. Will a new fusion of creativity and conservatism allow Bloomington to flourish? Will our known qualities of beauty, culture, community generosity, and buttoned-down nonconformity continue to blossom?

## Downtown Historic District

The first Monroe County Courthouse was a temporary log structure that was erected by settlers in 1818. After laying out the public square that surrounded the courthouse site, settlers quickly snapped up the lots at auction. By the following January, thirty families resided around the courthouse square. Bloomington was born.

In 1826 the townspeople replaced the deteriorating log structure with a bright red two-story courthouse. Local blacksmith Austin Seward wrought a fanciful copper fish weathervane to mount on top. Some say he made it to honor the reigning Jeffersonian Republican Party while others claimed that a fish was crafted because it was easier to make than more obvious symbols. Whatever the case, the weathervane had a disturbing tendency to fail to point into the wind, which surely made it an apt symbol for Bloomington.

Led by "Mr. Courthouse," H.B. Gentry, the local leaders dedicated a new courthouse in 1908 to replace the 1826 building. The stately Beaux Arts-styled structure's dome, columns, sculptures, and classical ornamentation resonated civic dignity. The county fathers had the propriety to reinstall Seward's now gold-leafed fish on the new dome, where it continues to overlook Bloomington. The monuments on the courthouse grounds reflect the tides of the county's sensibilities. They include war memorials to honor soldiers of the Civil War, World Wars I and II, and the Vietnam War. A thirteen-foot-high limestone statue erected in 1979 named "Mother of Mankind," celebrates peace with inscriptions and symbols. A stone slab commemorates 1910, when Bloomington was the population center of the United States. Nearby, a Women's Christian Temperance Union water fountain admonishes, "Drink and Be Grateful."

The courthouse square's collection of vintage buildings range from the 1840s through the 1930s. Though built on four different elevations over several decades, the buildings' casual architectures emerged from shared aesthetics, rather than following dictates of prescribed standards. Today the square reflects Bloomington's diversity where an Asian clothing shop can be found next to an attorney's office and an Afghani restaurant next to a billiards parlor.

Diners can choose among Italian, French, Greek, Irish, Croatian, Asian, New American, old American, and a European-style bakery within a few blocks of the square. Ambitious souls can peruse fine jewelry fashioned from fossils, Peruvian folk art, high-tech computer games, bookstores, art galleries, a cooking store, and an array of gift and clothing stores. The diversity on the square continues as you can also take yoga and Pilates classes, get a spa treatment, file a law suit, close on a house, and shop for groceries all within walking distance.

## Historic Neighborhoods

Since the university moved to Dunn's Woods in 1884, Kirkwood Avenue has served as the link between town and gown. Today the marquee of the splendidly renovated Buskirk-Chumley Theater glows with neon, as it did in 1922 when it opened in a flare of Hollywood-inspired glory. The beneficiary of an extraordinary public, private, and community consortium, the theater is operated by

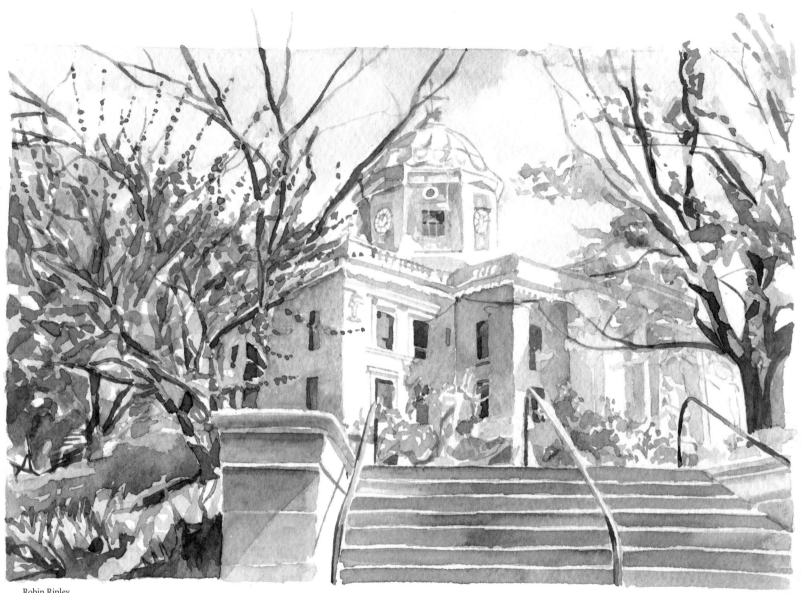

Robin Ripley

*Blooming redbuds and crabapples*
*surround the Monroe County*
*Courthouse in downtown Bloomington.*

a volunteer board, which oversees the professional staff. Rambling east toward the university, Kirkwood Avenue is an architectural hodgepodge of post-WWII commercial development, interspersed with specimens of fine architecture. It's a charming, well-loved strip of bars, restaurants, clothing, art and record stores, banks, churches, and the award-winning Monroe County Public Library.

The limestone Sample Gates at the end of Kirkwood provide a Gothic entry into the Old Crescent district of IU, the oldest part of the campus. Presided over by Maxwell Hall's limestone gargoyle, the nine buildings in the complex were built between 1884 and 1908. A whimsical mixture of Gothic and Spanish Revival styles, the 1912 Rose Well House was the spot where young women students traditionally became coeds with a kiss—a ritual that endures today.

Between the years 1925–1940 the campus spread down the hill toward the River Jordan and south to Third Street. A style of collegiate Gothic leavened with touches of Art Deco predominates among the buildings that include the Indiana Memorial Union, Myers, Rawles and Swain Halls, and the Wells Quadrangle. The tiny Tudor-style Beck Chapel overlooks the old Dunn Family cemetery—kite-shaped, it is said, to assist flights heavenward.

Dedicated to culture and the arts, the Fine Arts Plaza is centered on sculptor Robert Laurent's "Birth of Venus" statue, and a site of endless student pranks. There is a story told about the fountain that dates back to its construction in the late 1950s. Shocked by Venus' voluptuous nudity, the Hoosier workmen erecting the fountain refused to continue. Concerned administrators went into President Herman Wells' nearby office to alert him to the trouble. Wells stopped his paperwork to saunter over

to the work stoppage, where he listened to the workers' concerns. Proceeding to offer a short overview of Western art, Wells explained the ways this statue represented truth and beauty. Satisfied with his elucidation, the men returned to their labors.

The wedge-shaped I.M. Pei-designed Art Museum houses the university's outstanding collection of Mediterranean, Asian, Oceanic, and American art, as well as its fine collection of twentieth-century Western European art. Across the plaza, the Lilly Library is the location of one of the country's greatest collections of rare books and manuscripts. The Fine Arts Plaza, along with the nearby School of Music and IU theater complexes, form a concrete expression of President Herman Wells' dream to bring the culture of the world to Indiana.

Bloomington's historic residential districts provide a shady walk back to Hoagy Carmichael's student days—though thoughts are tempered by rap and hip-hop leaking from some houses. As the university prospered at the turn of the twentieth century, neighborhoods of imposing Queen Anne, Foursquare, Free Classic, and Colonial Revival homes began stretching up north Indiana Avenue for professors, business owners, and professionals. In the decades that followed, prosperous business people built large family houses in Georgian, Tudor, Spanish Colonial, and Mission revival styles in University Courts on Fess and Dunn's red-bricked streets.

The Cottage Grove district north of Tenth Street developed just before the turn of the century as a welcoming warren of bungalows for Showers Brothers' workers. The Showers Brothers themselves colonized north Washington with imposing homes for their children and friends, near their own mansions on Walnut. The houses remained

Tom Rhea

The IU Art Museum, designed by noted architect I.M. Pei, uses a triangular motif inside and outside.

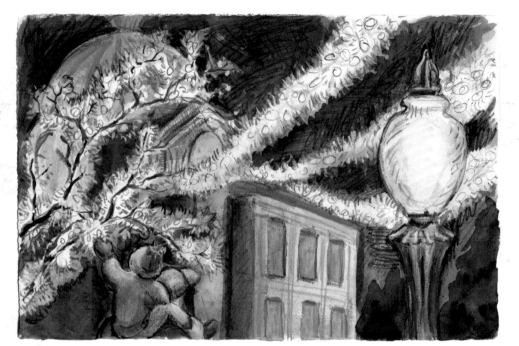

Bridgette Z. Savage

The Canopy of Lights is a Bloomington tradition bringing the spirit of sharing and joy to the courthouse square. Against the backdrop of the restored historic downtown, the Holiday Season opens with this cherished community event.

A westward view of storefronts and the Buskirk-Chumley Theater along Kirkwood Avenue in downtown Bloomington.

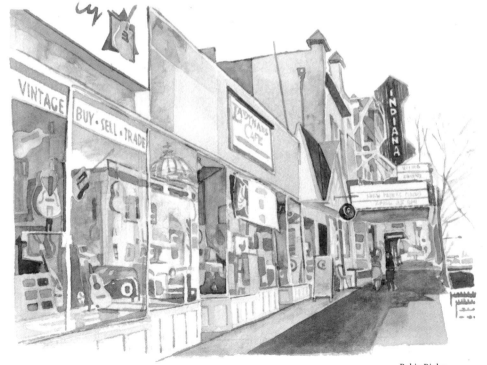

Robin Ripley

prestigious addresses well into the twentieth century, until the post-WWII demand for student housing transformed them into apartment houses. Over the last few decades, determined preservationists have restored the streetscape to a reflection of its former glory.

Vinegar Hill, southeast of the university, was a locus of inexpensive student housing in Hoagy's day. The rotting apples falling from the many derelict orchards gave the neighborhood its name. The post-World War I surge of the limestone industry provided the capital and expertise for construction of a remarkable collection of Vinegar Hill limestone houses. Italian and German stonecutters raised many, embellishing them with Art Deco and revival-styled limestone carvings. Dr. Alfred Kinsey was among the many luminaries who made the district their home, living for decades at 1320 East First Street. He was an obsessive gardener, and, according to historians, conducted some of his human sexuality research here. The neighborhood retains its upper-middle-class prestige, housing the latest generation of professionals.

Southwest of the square, a rounded hill topped by the 1840s Federal-styled Paris-Dunning House became the center of another elegant Victorian neighborhood—Prospect Hill. Families built upscale houses in a variety of styles on the crest of the hill and down Rogers Street. Unlike the other affluent neighborhoods, however, worker cottages surrounded the professionals' housing, giving Prospect Hill an interesting flavor of interwoven diversity. Today, the revitalized neighborhood remains a colorful mixture and is home to university people, professionals, civil servants, artists, students, and retirees.

The northwest side of Kirkwood retains some mid-nineteenth-century farmhouses at its eastern edge and hundreds of early twentieth-century worker cottages. In the mid-1990s the redevelopment of the former Showers Brothers' factory into the public-private Showers Plaza accelerated prospects for the westside. The neighborhood's increasing numbers of artists, designers, antique shops, and quirky cafés serve as an indicator for a vibrant resurgence.

## Uniquely Bloomington

From the thin promise of early May until the cold rains of October, the Saturday Farmers Market at Showers Plaza serves as a community gathering place. Amish farmers, local growers, and retired hobbyists line the aisles with their tables of goods. A local bakery offers European-style breads, there are farm-fresh eggs, honey and beeswax products of every description, and the regulars have grown to depend on seeing the lady with chili peppers in the same location every week. Artist-growers present their flower arrangements and perennials, and those who prefer the unusual can find a variety of mushrooms and goat cheese.

The scent and color of passing seasons hang in the air as tender greens and spring flowers give way to basil, melons, and a riot of summer blooms. Corn careens into the market piled onto the back of farm trucks, tomatoes arrive in time for July 4th picnics, and suddenly those selling pumpkins, mums and maple syrup have customers waiting in line. Music can be heard from different corners of the market. An acoustic guitarist picks out tunes beside an open case, while a Bluegrass band performs on the bandstand. Jazz alternates with folk. One week a dance troupe, the next a local chef offering a cooking demon-

stration, can be found on center stage. At the market's perimeter, a broad range of volunteer organizations offer their views, pamphlets, and pleas for involvement in their cause.

This is contemporary Bloomington at its finest: a small, southern Indiana city that somehow attracted the world. As former Mayor John Fernandez said, "It's just so Bloomington. It's one of those things you point to and say, 'This is why I live here.'"

Bloomington has also been referred to as "Little Tibet." Buddhist monks can be seen on occasion around town. Members of Bloomington's thriving Tibetan community operate two Tibetan restaurants and an international café. The Tibetan Cultural Center head, Thubten Norbu, is the older brother of the Dalai Lama. He fled Tibet in 1951 in the face of Communist Chinese invasion and landed in Bloomington in 1965 to teach at IU's respected Central Eurasian Department. After almost forty years in Bloomington, Professor Norbu says, "You can say I'm 93 percent Hoosier."

Bloomington has long been a melting pot of religious thought. Nearly fifty churches of all sizes—protestant, Catholic, and non-denominational—offer spiritual guidance to all who seek it. There is a Jewish synagogue, an Islamic Temple, spiritual centers, Christian schools and daycares, as well as religious campus centers to serve the university students.

Bloomington has been moving to a musical beat for a long time—from the Gentry Brothers' circus music and Hoagy's Jazz Age to the rock and folk revolution that erupted in the 1960s. Through the decades, music defined Bloomington, and the town, in turn, shaped the music. Hoagy wrote about Stardust and Bloomington: "That one's all the girls, university, the family, the old golden oak, all the good things gone, all wrapped up in a melody." John Mellencamp, originally from Seymour, Indiana, has made Bloomington his home, and records from his studio on the outskirts of town.

Even with its history of music, Bloomington had never seen anything quite like the Lotus World Music and Arts Festival that began in 1994. Over the years, hundreds of the world's most celebrated musicians—many considered to be living treasures in their home country—played downtown stages. At this music jam each September, music lovers can hear Latin, African, Celtic, Middle Eastern, European folk, Asian, American folk, blues, bluegrass and Cajun. The Fourth Street Festival and the Taste of Bloomington are other popular festivals that have had long runs.

However Bloomington evolves, there is one component that remains the same. Ornament, structure, bedrock—limestone is the great defining element of our town. Limestone had its origin in the shallow inland seas that covered this part of Indiana about 340 million years ago. For eons, trillions of creatures—crinoids, gastropods, and other diverse sea entities—lived out their lives in teeming proximity. Where currents gently funneled the creatures, vast shoals arose. As the continent migrated north over millions of years, the great weight of water pressed the shoals into rock. When the great glaciers ground the rest of Indiana into a tabletop over a period of a million years, they stopped short of southern Indiana, leaving a slender band of ancient reefs throughout Monroe county—our Indiana limestone. Often referred to as the "nation's building stone," nearly 80% of the dimension limestone used in the U.S. is quarried in Indiana, including that use in the Empire State Building, the Tribune Tower in Chicago, and

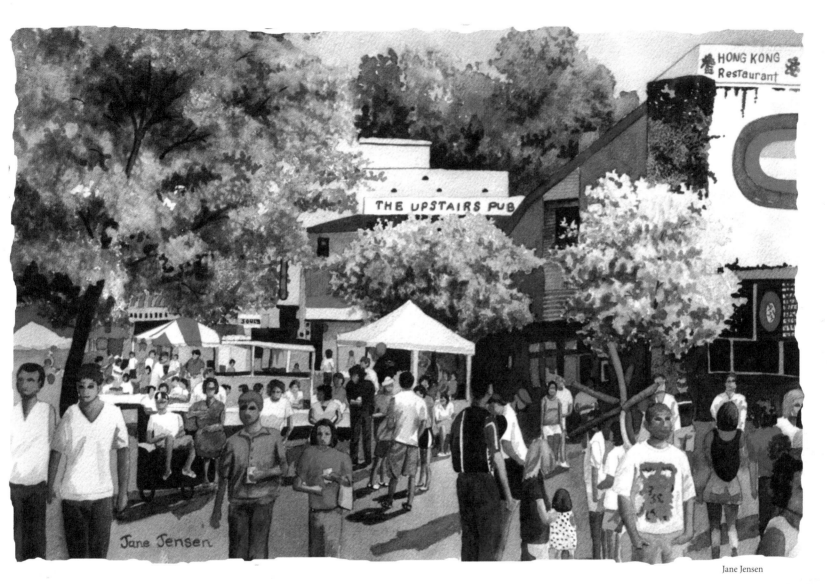

Jane Jensen

Hoosier Fest was a popular event for 20 years where street vendors were plentiful and live music entertained the public.

Robin Ripley

Redbuds bloom at an old limestone quarry near Victor Pike and Fluck Mill Road in southwest Bloomington.

the National Cathedral in Washington, D.C.

Today we stumble over outcrops while following century-and-a-half-old limestone boundary walls, take shelter in limestone buildings, and admire the statues and gargoyles wrought from its malleable form. At Kirkwood and Walnut, a wall displays a cluster of fossilized sea creatures, which seemingly illuminates all our limestone's ages. One can imagine stone workers a hundred years ago spotting the fossils and cutting the slab for us to admire—ancient accidental art displayed for our continuing wonder and enjoyment.

## Life in Bloomington

Many years ago a somewhat mystical friend of mine claimed that Bloomington owes its tolerance and variety to our location on an ancient reef. According to this friend, reefs sustain the earth's greatest density of life forms in the smallest possible space. It's us, he said.

Now I leave it to you to decide who among us is a thriving gastropod and who is a fossil, but I figure it's as good a theory as any to explain this phenomenon of generally forbearing diversity, located in the hills of Indiana. Over the last few hundred years, we have built a community. We're intelligent, though perhaps somewhat over-educated. It means many with an informed opinion want to be heard before a decision is made. No wonder city council meetings last until 1:00 a.m. We've evolved some unique harmonies and added our viewpoints to the world's discourse. We're entrepreneurial as well as artistic. Academics and free spirits co-exist with a common sense working population. Best of all, we're accepting. Like I said—It's a good town.

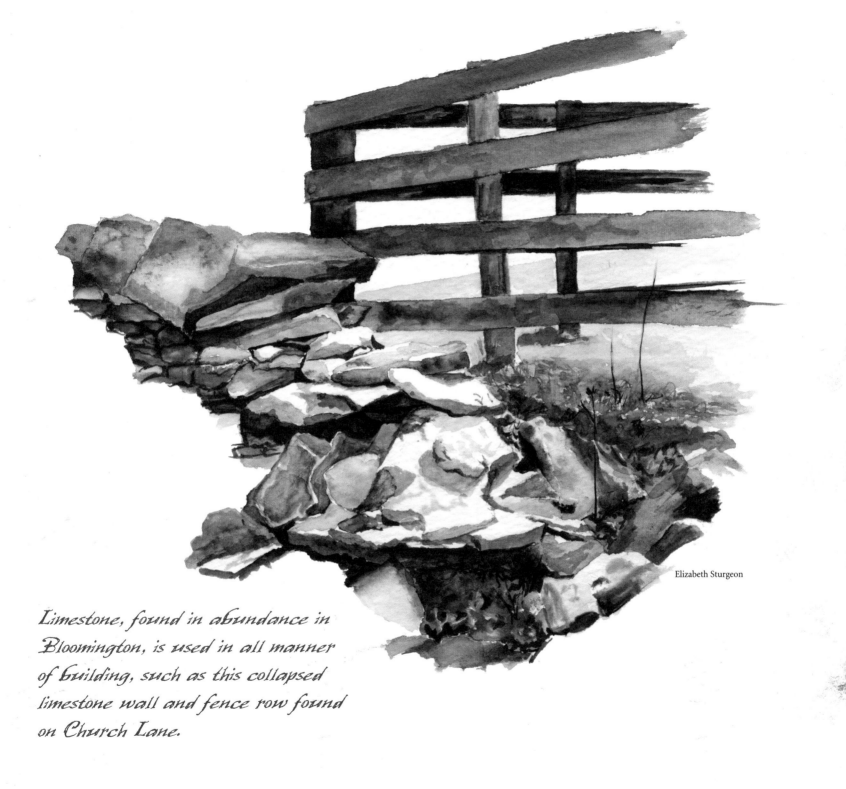

Elizabeth Sturgeon

Limestone, found in abundance in Bloomington, is used in all manner of building, such as this collapsed limestone wall and fence row found on Church Lane.

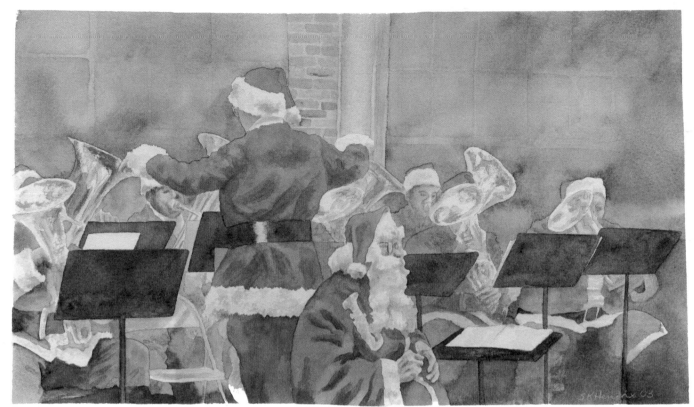

Suzanna Hendrix

*Above, The Harvey Phillips Tuba Santas. Harvey Phillips is a Distinguished Professor Emeritus of the IU School of Music.*

*At right, Children play soccer at Karst Farm Park during the spring and fall season in Bloomington. Here, they spend a moment in a huddle with the coach.*

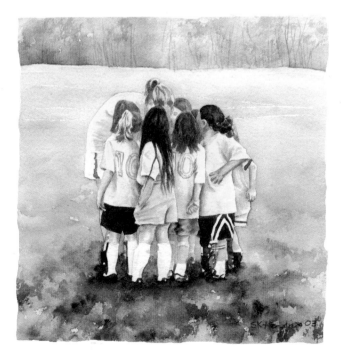

Suzanna Hendrix

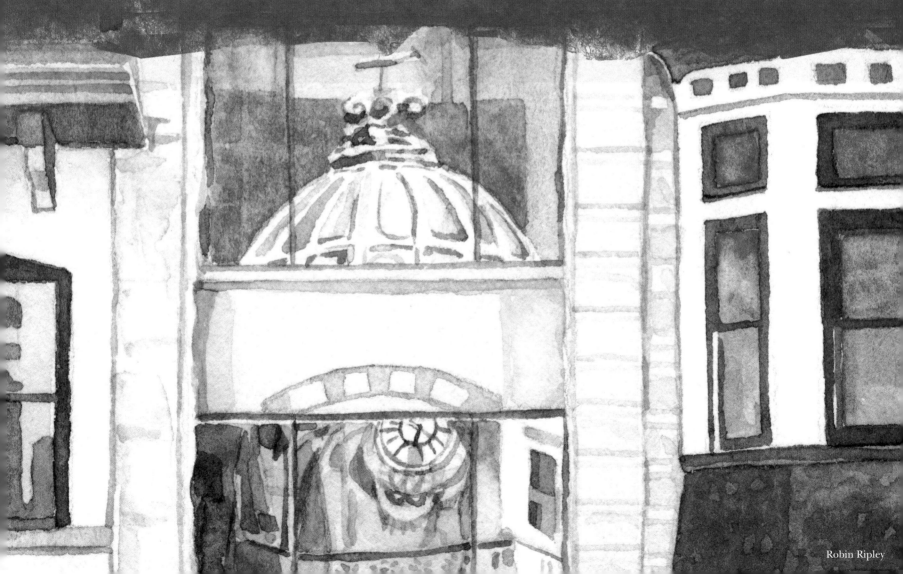

Downtown

Robin Ripley

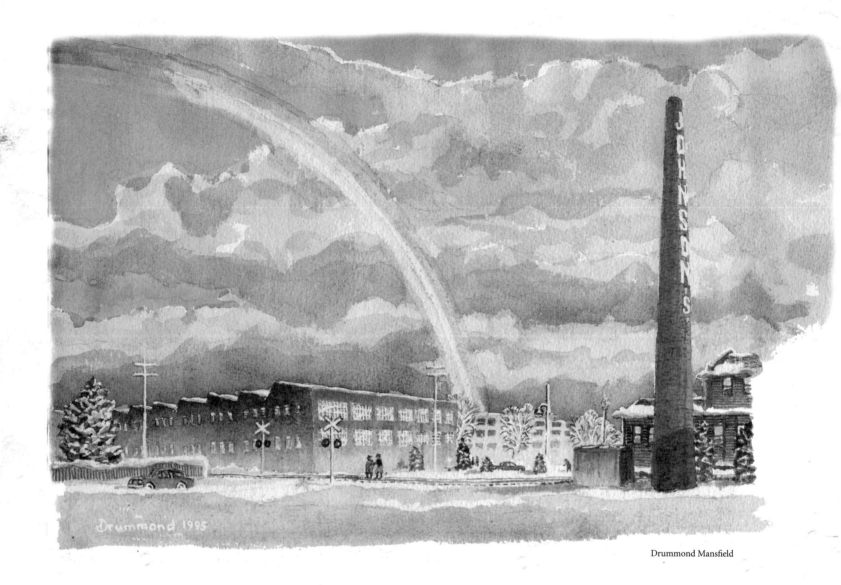

Drummond Mansfield

Chimney of old Johnson Creamery. In the
background are the buildings of the Showers
Furniture Factory.

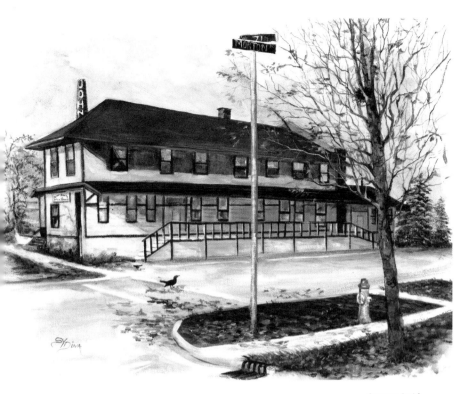

Sammye Smith

The old Illinois Central Railroad freight depot at 301 N. Morton St. In 1971, it was designated an historic landmark by the city. Built in 1906, it served as the center of trade in Bloomington for nearly seventy years.

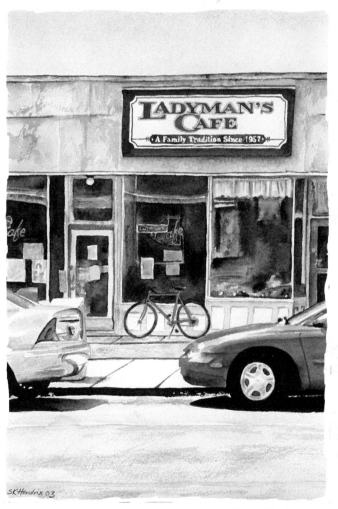

Ladyman's Café has been a part of downtown Bloomington for decades. As the sign above the door states, it's been "A Family Tradition".

Suzanna Hendrix

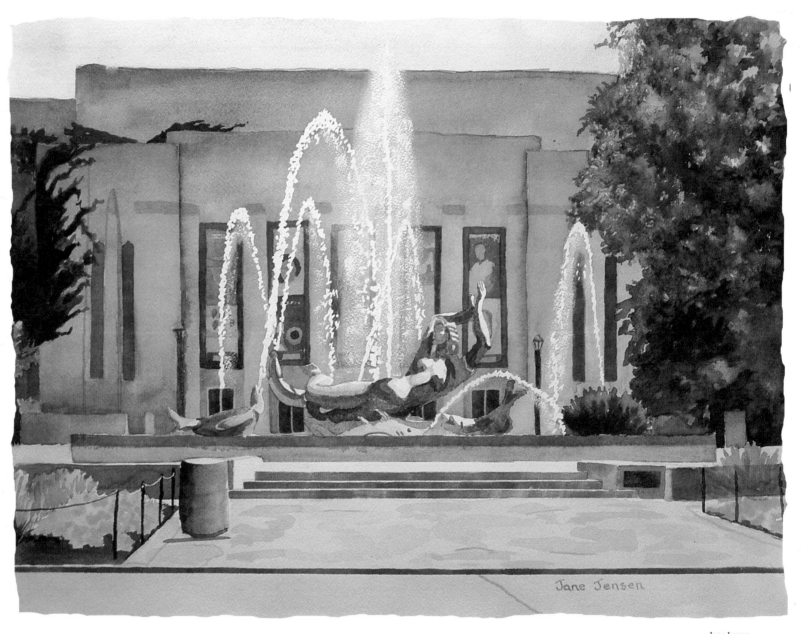

Jane Jensen

Artist Robert Laurent first submitted designs for the Showalter Fountain in 1954 featuring his sculpture, "The Birth of Venus." Dedicating the fountain in 1961 was one of Herman B. Wells' last acts as president of IU. This is the east view of the IU Auditorium, a 3,200 seat facility, which hosts celebrity performers and Broadway touring companies.

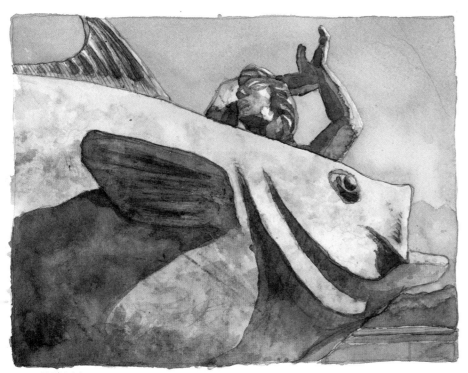

Donald F. Madvig

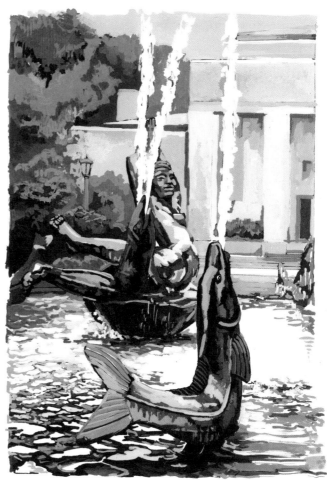

Tom Rhea

Donald F. Madvig

MADVIG

The Showalter Fountain has long been a symbol of the IU campus, and is the traditional "dunking ground" for local high schools following graduation ceremonies. It stands proudly in a circle surrounded by the IU Auditorium, the Fine Arts Building, and the Lilly Library.

31

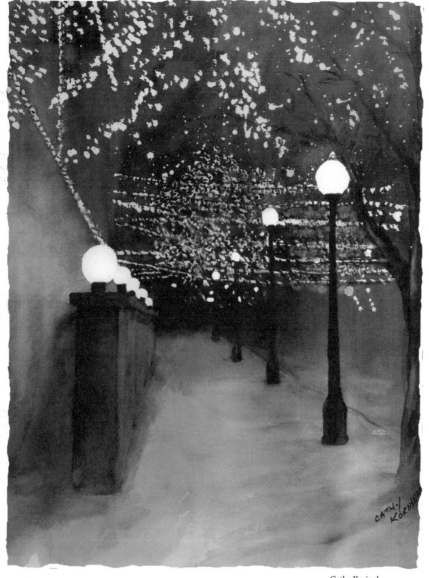

Cathy Korinek

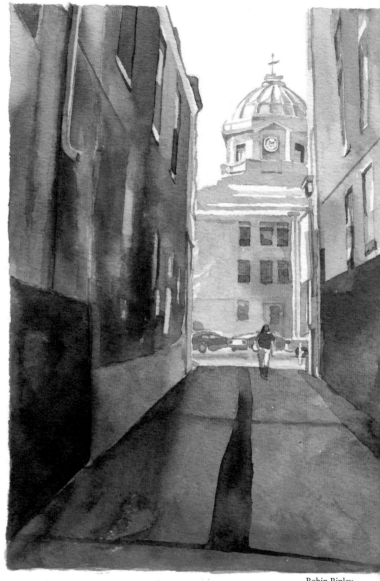

Robin Ripley

*The holiday lights on the east side of the Fountain Square mall are a great attraction during Christmas time.*

*An eastside view of the Monroe County Courthouse is seen from an alley off of Walnut Street.*

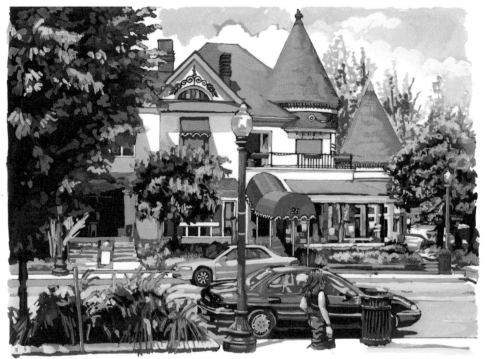

Pedestrian shopping on *Kirkwood Avenue* remains one of the most characteristic and charming aspects of life in *Bloomington.* Unusual, old *Victorian* houses still remain, such as *Victorian Towers,* now home to shops and restaurants like *Shanti,* serving Indian cuisine.

Tom Rhea

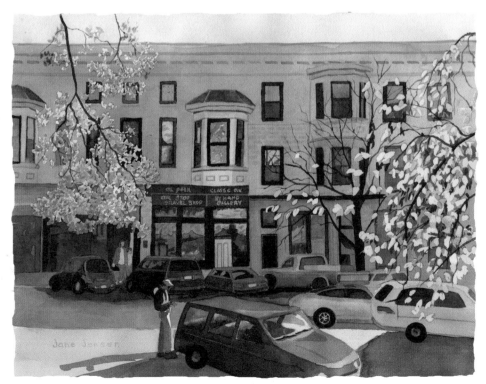

*A fall scene of the southside of Bloomington Square on Kirkwood.*

Jane Jensen

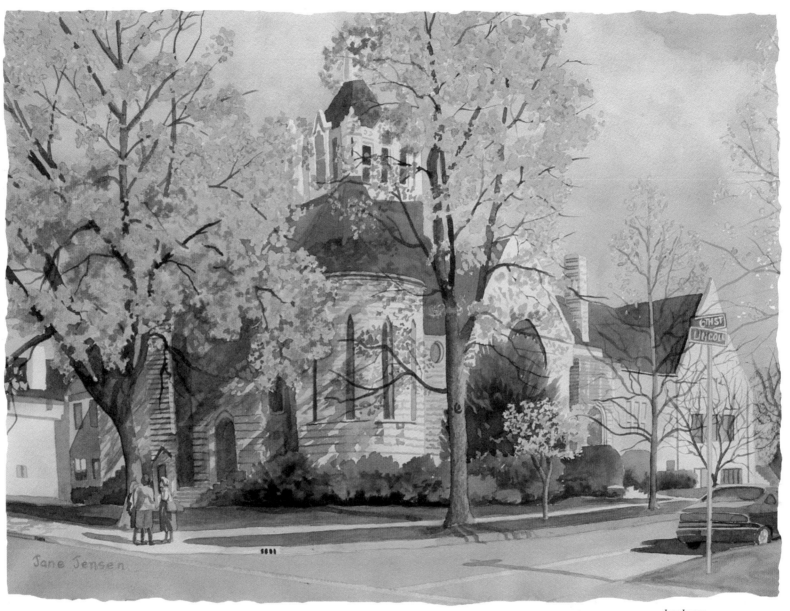

Jane Jensen

The oldest church in Bloomington is the First Presbyterian Church at
6th and Lincoln St. Its cornerstone was laid on July 9, 1900.

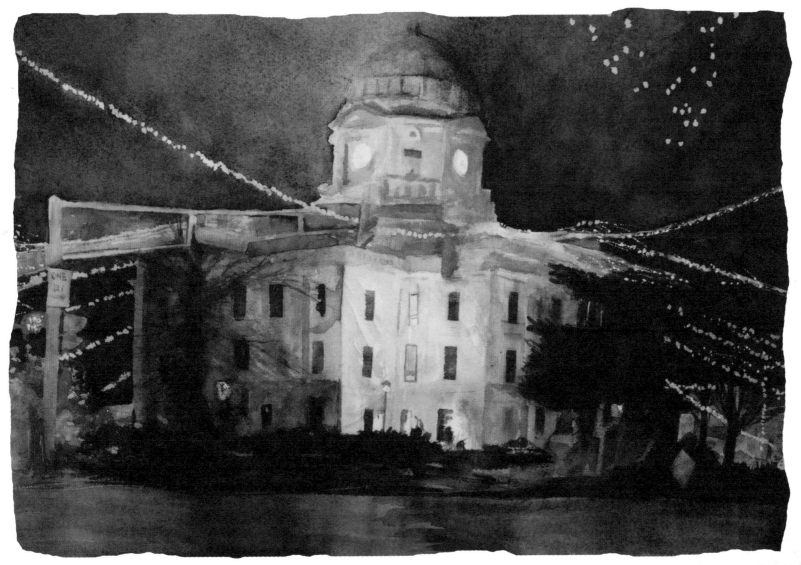

The Monroe County Courthouse at night during the holiday season with its "Canopy of Lights". The Courthouse stands proudly over its community and is a steady guide for the citizens.

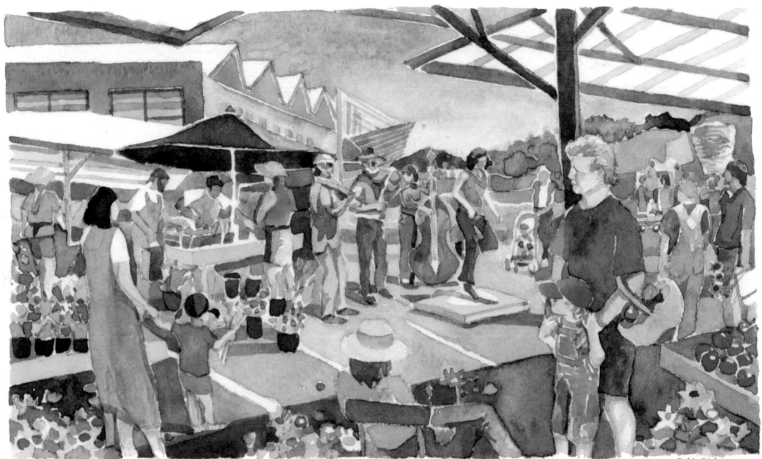

Robin Ripley

People gather on Saturday mornings
to shop for vegetables and plants,
and to see and hear performers at
the Bloomington Community Farmers
Market at Showers Common.

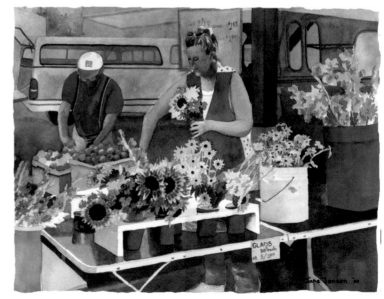

Jane Jensen

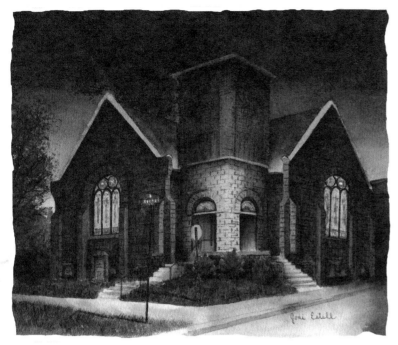

Jodi Estell

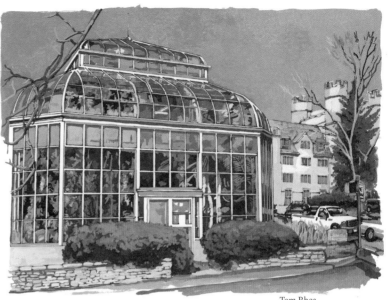

Tom Rhea

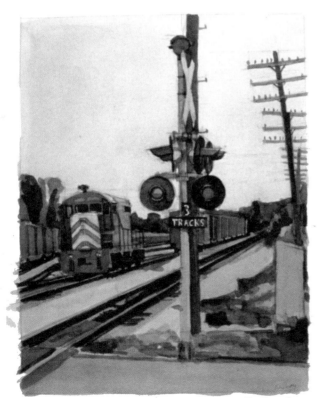

Tim Kennedy

Above left, Second Baptist Church. Designed by Samuel Plato, a black architect, and built in 1913.

Above right, The Greenhouse on East Third Street supports the botany research in nearby Jordan Hall. Gleaming like a jewel in the autumn sun, the greenhouse stands before the distinctive towers of Memorial Hall.

At left, the railroad swiching yard near Grimes Ave.

37

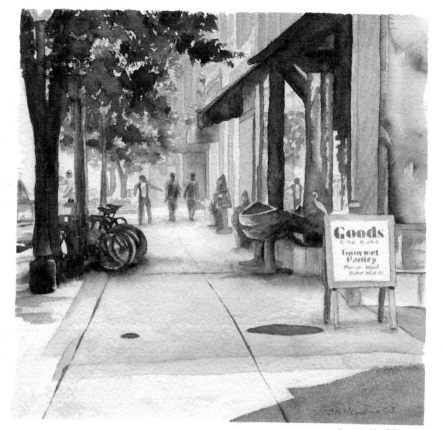

Suzanna Hendrix

Top left, With summer comes the pleasure of cruising the Courthouse Square. On foot, rollerblades or a bike, enjoying the downtown area is always interesting and unique.

Bottom left, Goods for Cooks has been a staple on the square for years. Many locals visit Goods for this gift-giving needs.

Below, Limestone carving of 18th-century lovers set in the wall of 501 E. Third on the west side facing Dunn St.

Judy Noyes-Farnsworth

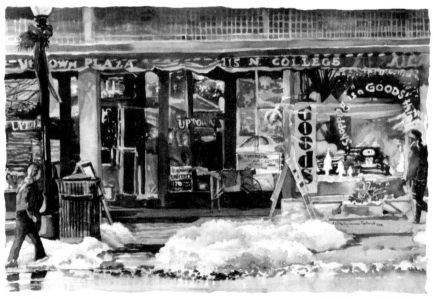

Shelley Cannon Frederick

38

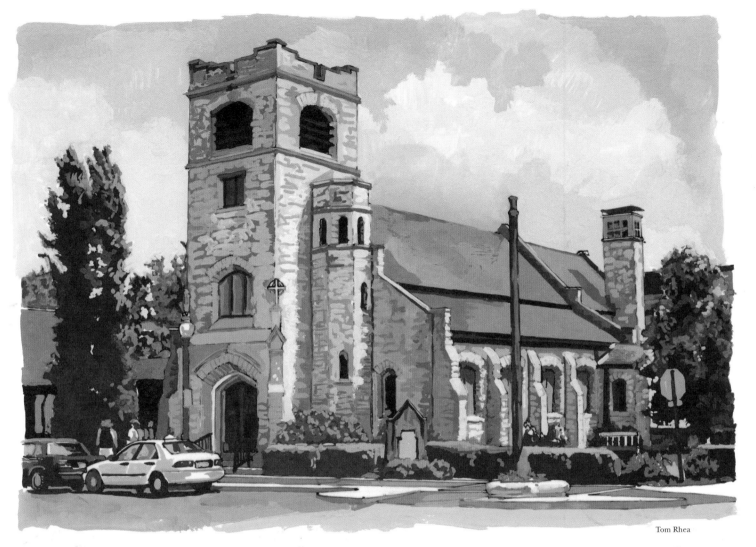

Tom Rhea

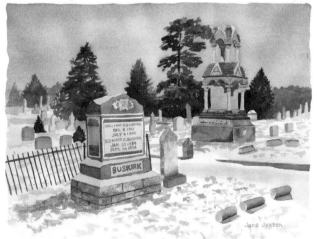

Jane Jensen

Trinity Episcopal Church was first established in
Bloomington as a mission in 1871. Its current stone
building was built in 1909.

At left, These two monuments can be found in the
Covenant Cemetery on West 3rd Street. The names Buskirk
and Waldron are very prominent in the history and makings
of cultural activities in Bloomington.

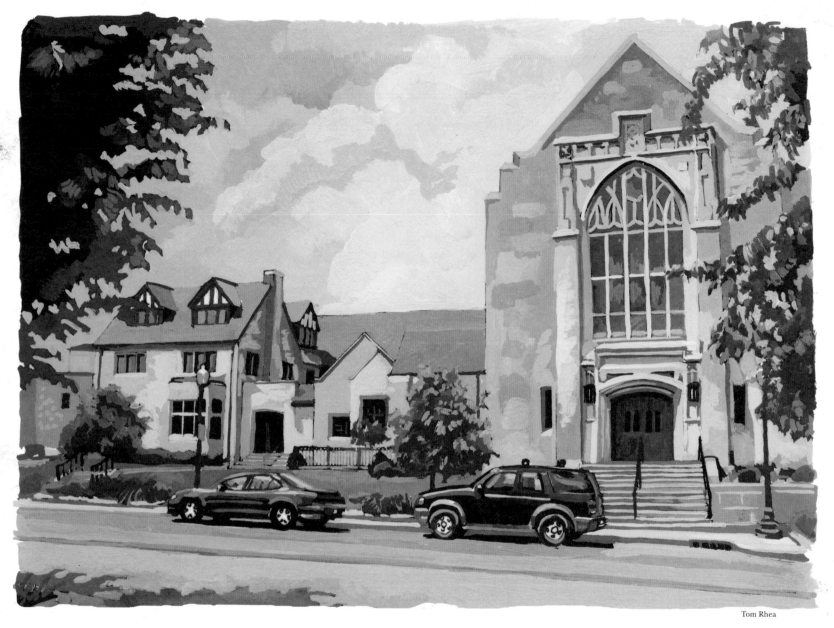

Tom Rhea

The First Christian Church at 205 East Kirkwood Avenue was originally built in 1917.
In 1921 the church was rebuilt after being destroyed by a fire.

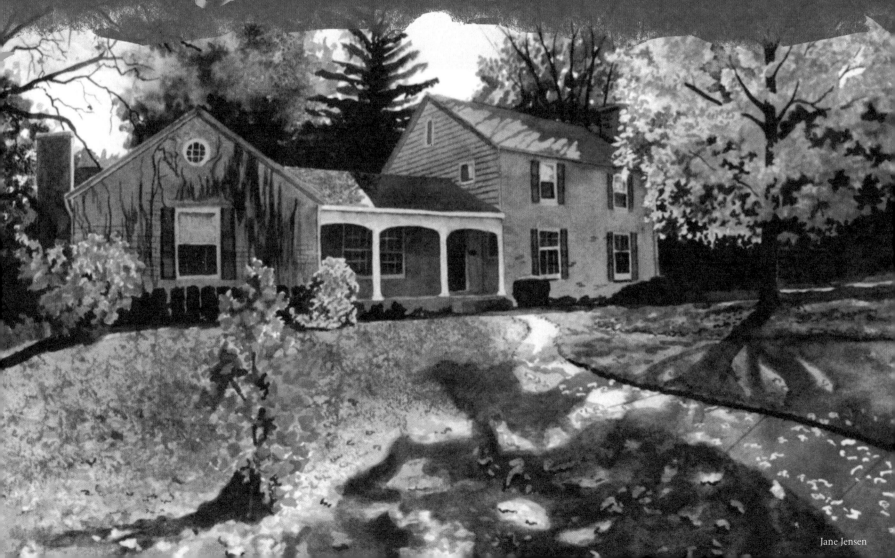

# Neighborhoods

Jane Jensen

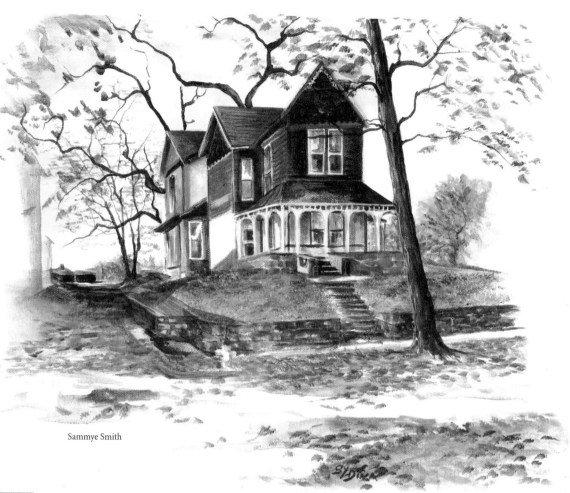

Sammye Smith

Donald F. Madvig

*Above,* This house at 419 N. Washington St. was built in 1891–1894. William Showers rebuilt the house in 1910. It is in the East Lake, Stick Style design.

*At left,* This example of classic Victorian architecture was built in 1895, and demonstrates what makes Bloomington not only a beautiful university town, but also a lovely hometown.

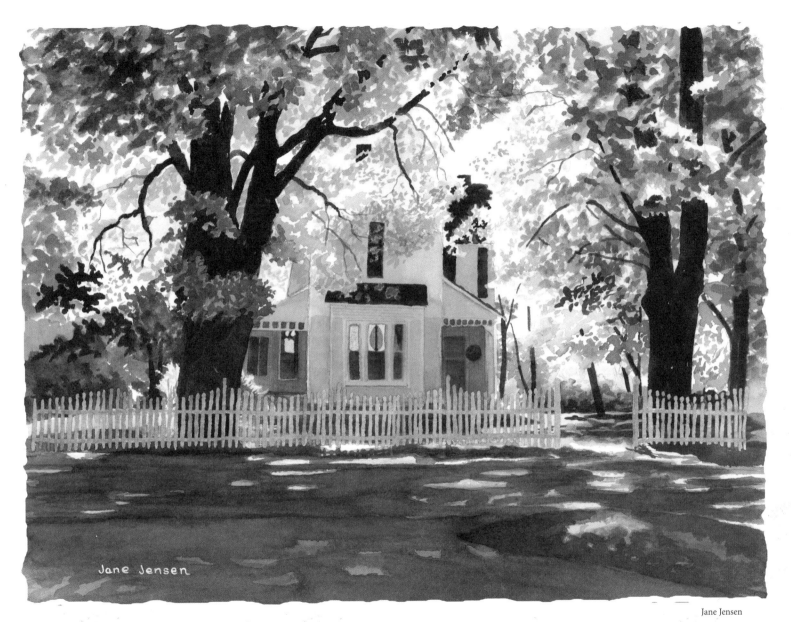

Jane Jensen

The Daisy Garton Farm House, located on East Tenth Street.
It is one of the oldest residences in Bloomington.

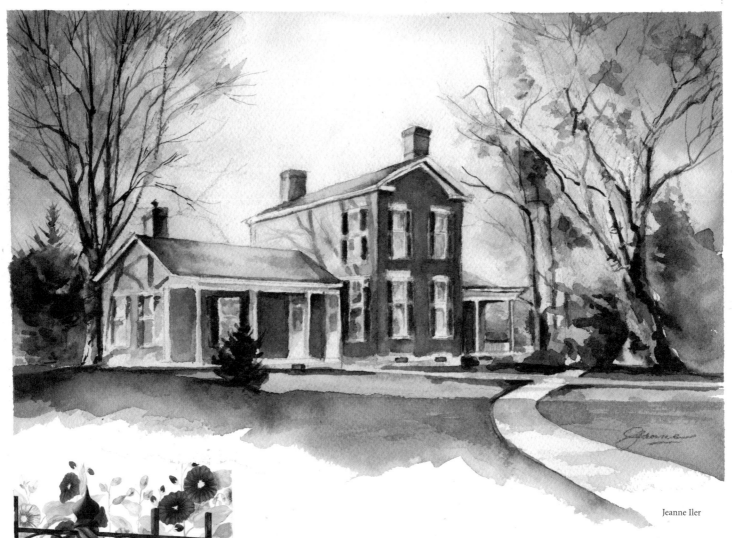

Jeanne Iler

Jodi Estell

Above, The Paris-Dunning house on Prospect Hill was built around 1845 and is listed on the National Register of Historic Places.

At left, Cast- and wrought-iron fence made by Bloomington blacksmith Austin Seward, ca. 1895, Prospect Hill.

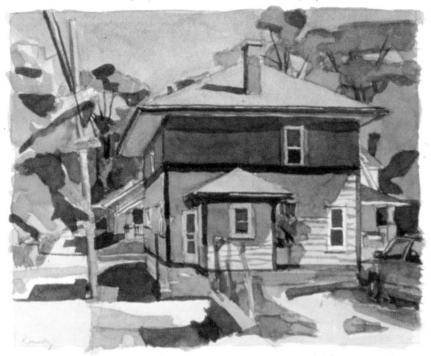

Tim Kennedy

Bloomington is filled with Foursquare houses and arts and crafts bungalows that have been converted into student housing. This is the view of one of these converted Foursquare houses on Second Street east of Henderson.

A small wreath of woven branches decorates the front door of this house located on Lincoln Street just below First on the east side of the street.

Tim Kennedy

45

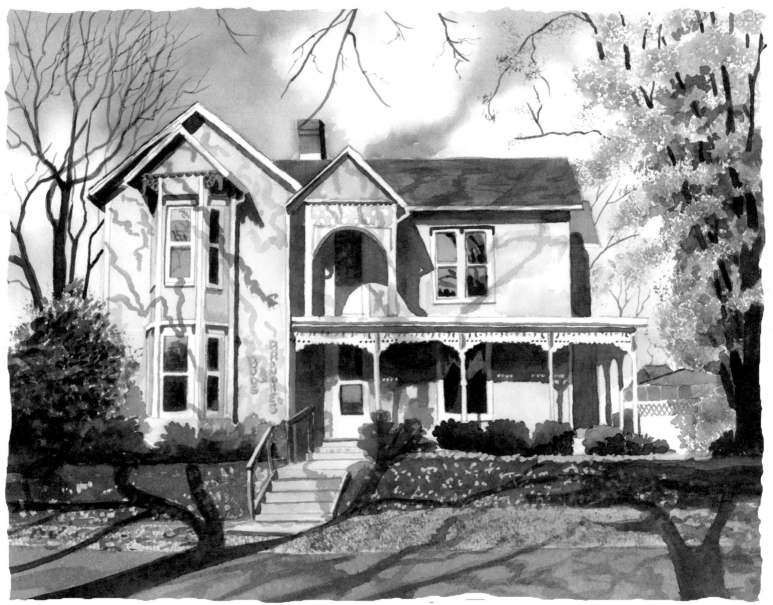

Jane Jensen

The Graves house, located at 608 W. Fifth St. It was built for the Graves family back in 1885. This two storied gabled-ell has a rich variety of Queen Anne detailing. The two-story projecting bay has its own bracketed gable. Decorative scrollwork adorns the wraparound porch and a small second porch has its own gable.

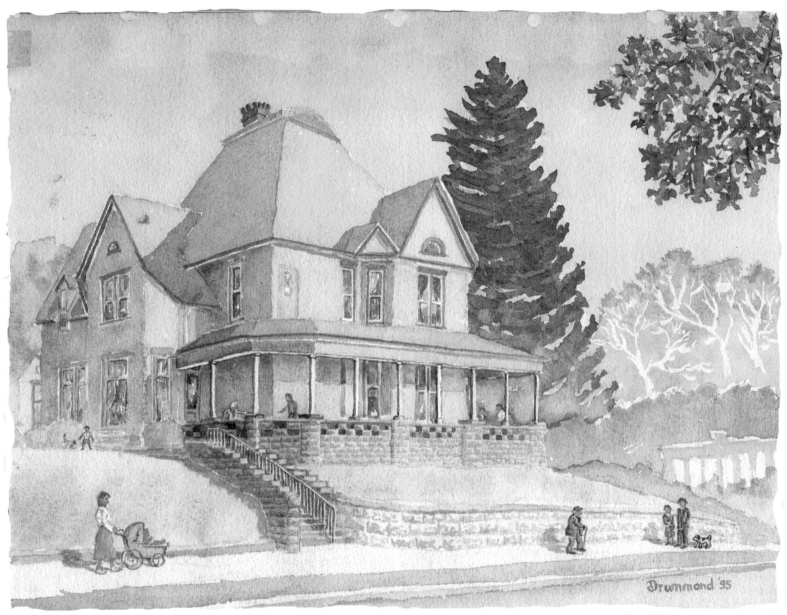

Drummond Mansfield

*A home in Near Eastside neighborhood of Bloomington on N. Washington St.*

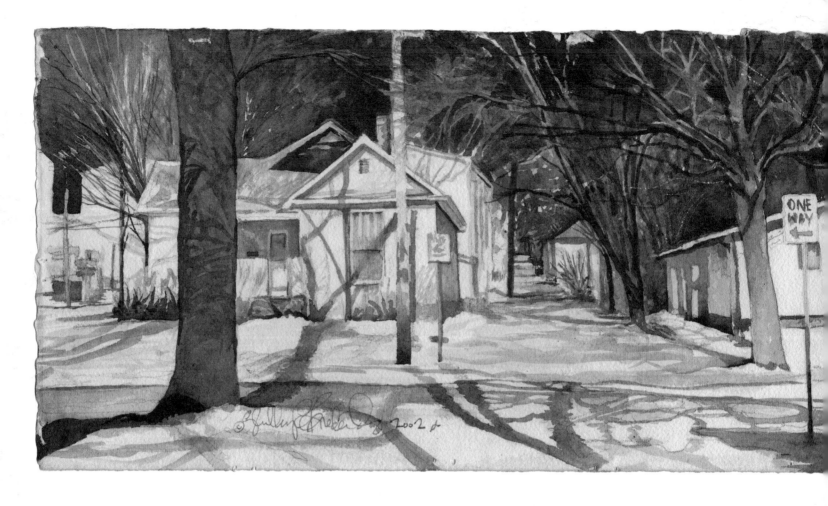

Above, A winters' twilight bathes a student rental in a peaceful evening glow on Tenth and Cottage.

Top Right, John and Mary Ann Matthews came from England in 1849. In 1867, with only the use of hand drills, ship wedges and blasting powder and stones dredged from the Matthews family quarry, the twelve-room mansion was built in Ellettsville, Indiana.

Bottom Right, The long shadows of late summer reach across the corner of Lincoln and Allen.

Shelley Cannon Frederick

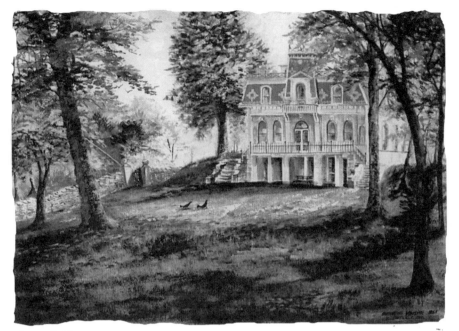

Sammye Smith

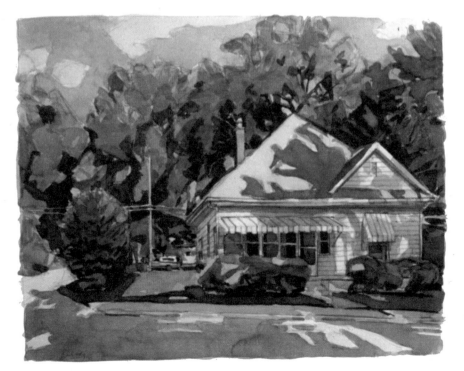

Tim Kennedy

*49*

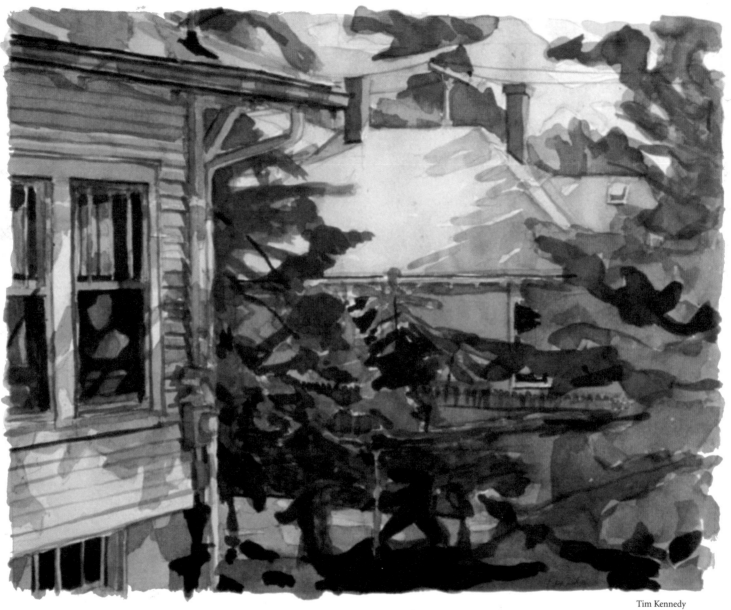

Tim Kennedy

*A view from a window of a one-time Bloomington parsonage.*

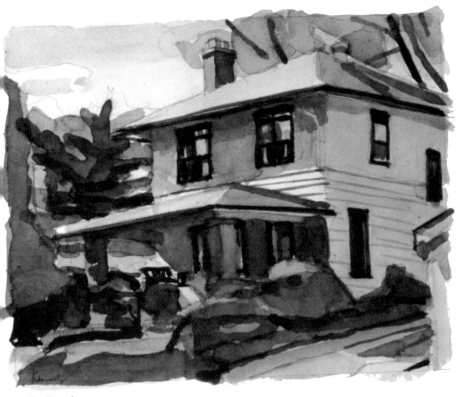

Tim Kennedy

A Foursquare home on University near the corner of Fess.

The Showers Bridwell house, located on 419 N. Washington St. William Showers built this Queen Anne style structure. In 1920, Showers sold the house to the Bridwells, who once owned a grocery store on 10th St. Notice the seven gables, the Queen Anne chimney and the steamboat porch added before 1907.

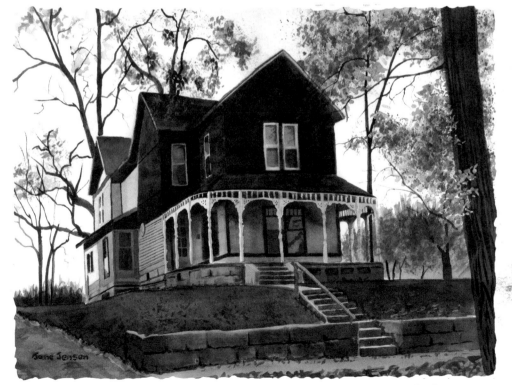

Jane Jensen

51

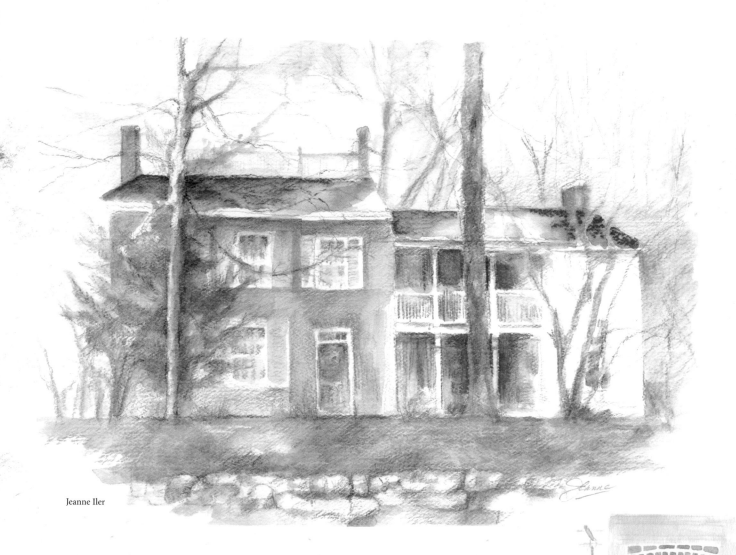

Jeanne Iler

Above, The first president of Indiana University, Andrew Wylie, had this beautiful home built in 1835 for himself and his family. It is on the National Register of Historic Places and is now a museum. Its location is at 317 East Second Street, Bloomington.

At right, An interior of the Wylie House.

Connie Brorson

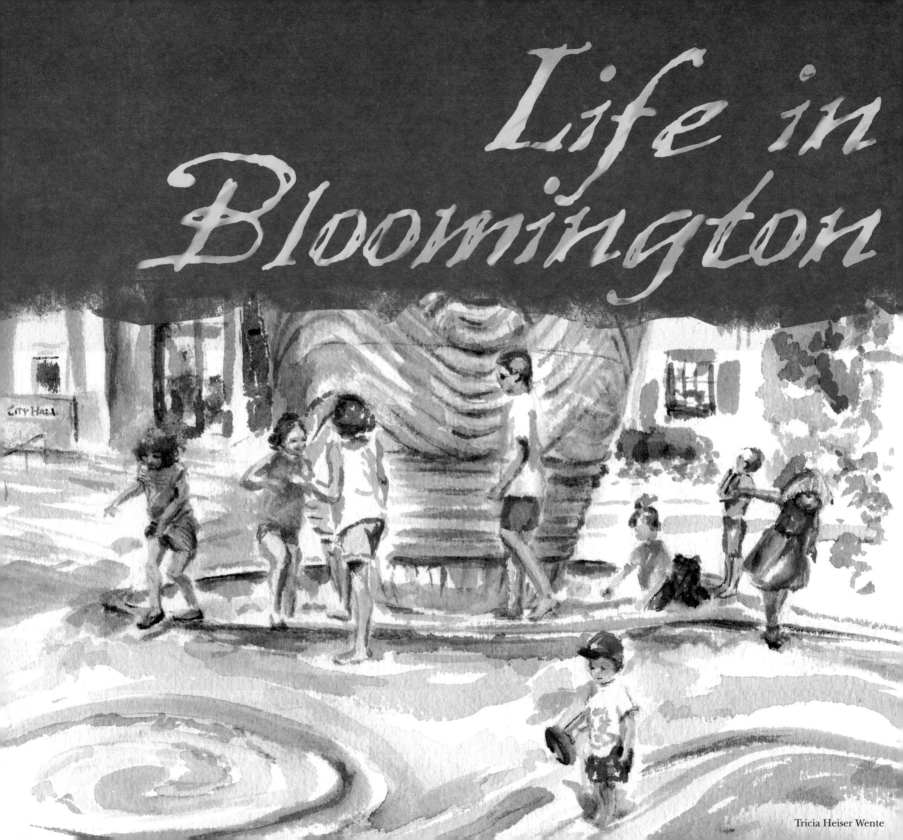
Life in Bloomington

Tricia Heiser Wente

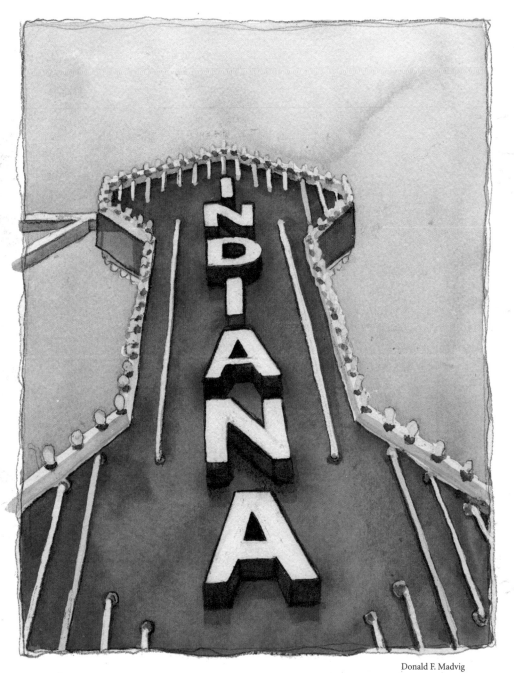

Donald F. Madvig

Indiana Theater Building (now Buskirk-Chumley theater).

Two gentlemen enjoy the morning paper on a park bench outside Showers Plaza.

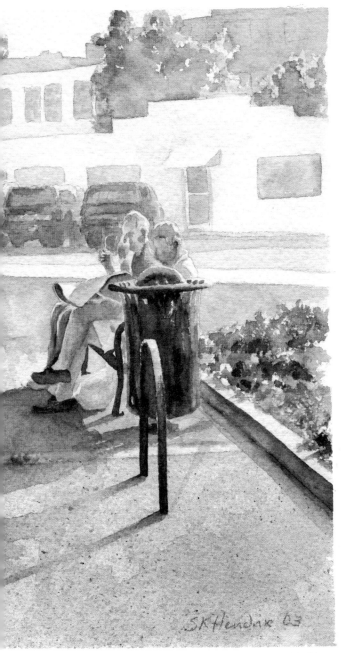

Suzanna Hendrix

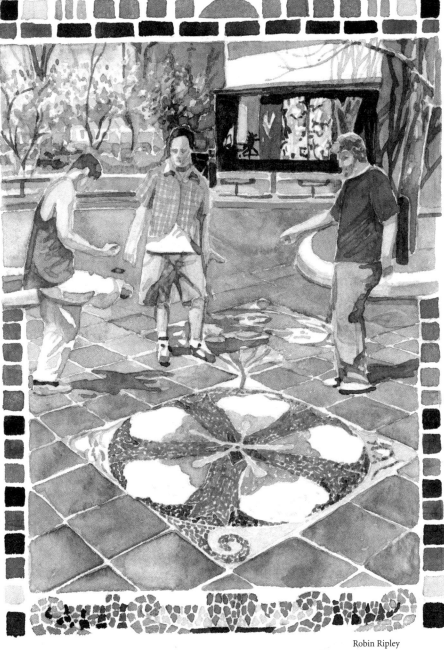

Robin Ripley

Students play hackey-sack near
the mosaics in Peoples Park in
downtown Bloomington.

BloomingFoods Coop, view from alley intersection, between Kirkwood & 6th streets on the alley in the block between Grant and Dunn.

Judy Noyes-Farnsworth

Janko's Little Zagreb is famous for its steak and garlic rolls, and is a very popular and unique restaurant in Bloomington. The building itself is typical of the architecture on the downtown square in Bloomington and was built of the large rough limestone blocks that are ubiquitous in the area.

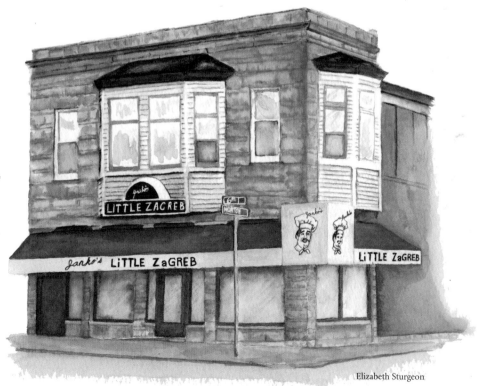

Elizabeth Sturgeon

56

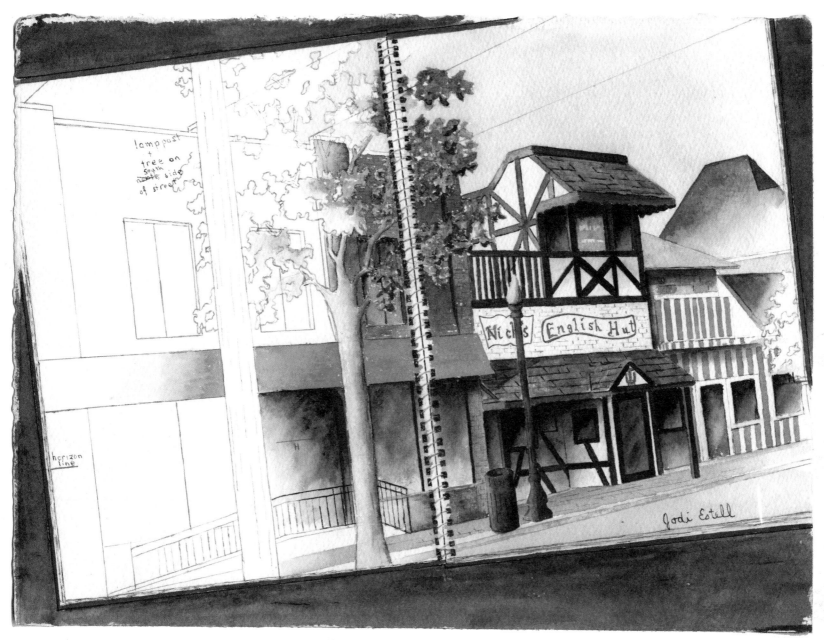

lamp post
+
tree on
south side
of street

horizon
line

Nick's English Hut

Jodi Estell

Jodi Estell

Just off of the IU campus, on East Kirkwood, Nick's has been a hot spot for students and alumni for over seventy-five years, especially after ball games. Students from the 1960s still talk about "Ruthie", their favorite waitress for decades.

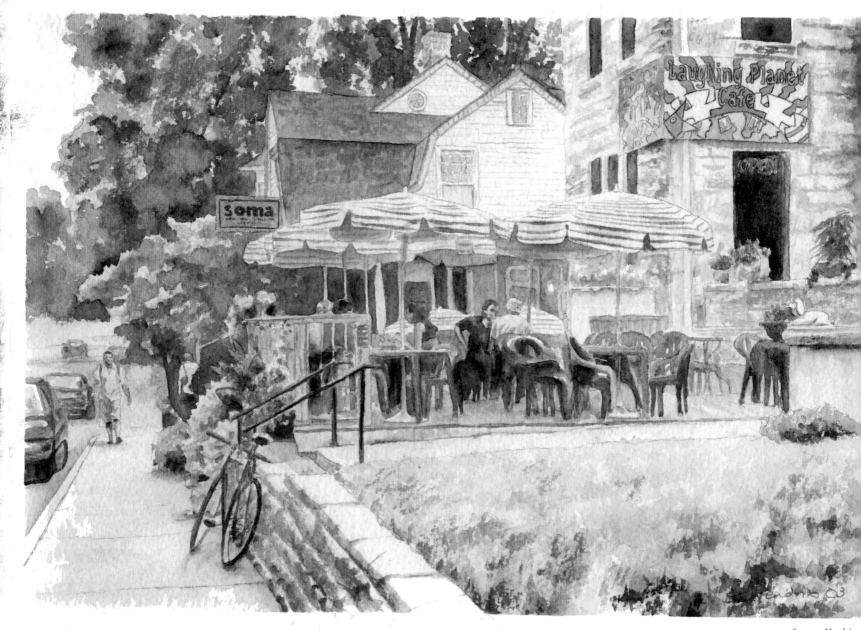

Suzanna Hendrix

Just off campus is the ever-interesting Laughing Planet Café. A unique little restaurant, you may enjoy your meal outdoors or in. Not only does the food excite your palate, they offer a feast for the eyes. On a fair day try the outdoor seating, as you can take in the colorful landscaping and passersby.

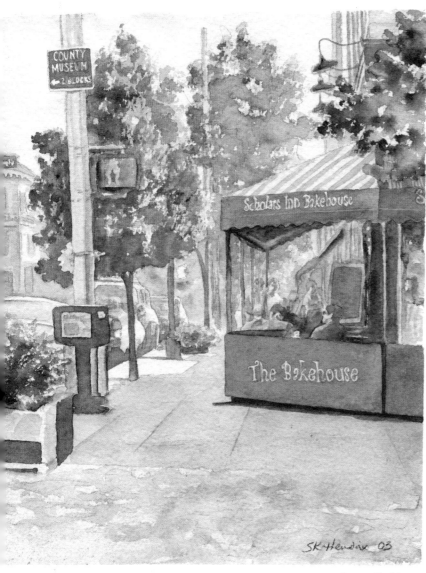

Suzanna Hendrix

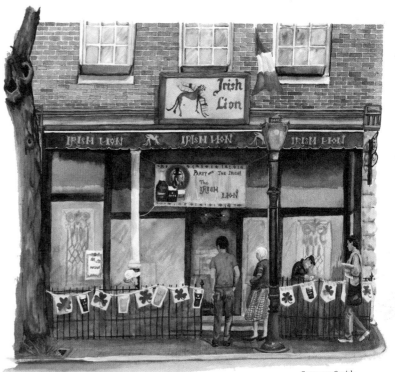

Sammye Smith

he courthouse square is home to numerous shops,
rt galleries, and restaurants. Because of the
onvenience, atmosphere, good food, and coffee, the
cholar's Inn Bakehouse has become a favorite
angout for many of the artists featured in the
Bloomington Sketchbook.

The Irish Lion Restaurant, located at
212 W. Kirkwood Ave. once was a bar
and brothel and was built around
1882. Only the ceiling is original. It
stood empty and dilapidated until 1981
when Larry McConnaughy purchased
the property and established the lively
Irish Lion restaurant in downtown
Bloomington.

59

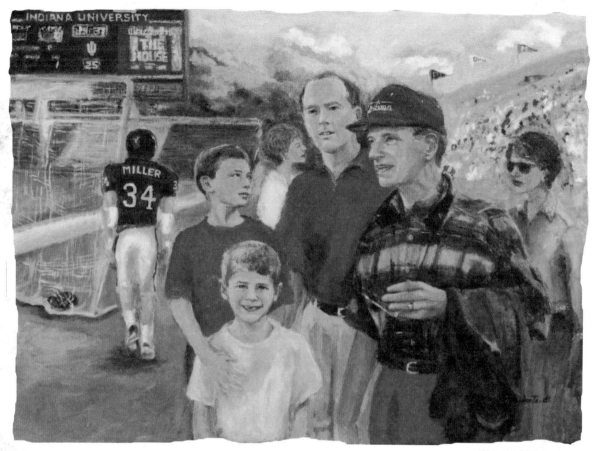

Tricia Heiser Wente

*Above, IU games are an institution for many residents, including the Abshire family.*

*At right, This scene is typical of Bloomington in early spring as bikers prepare for the well-known Little 500 race at Indiana University. The race was made famous in the 1979 movie Breaking Away.*

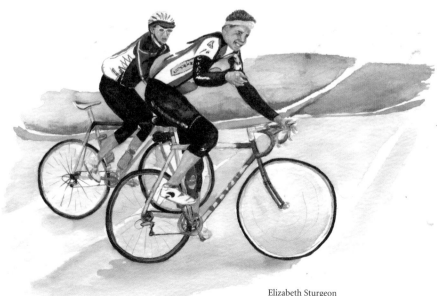

Elizabeth Sturgeon

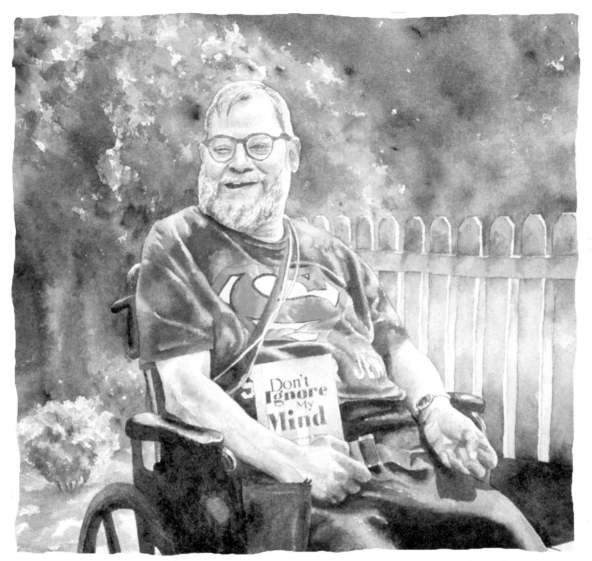

Suzanna Hendrix

As a child, Robert Kaplowitz and his family were told by the "experts" that he would never be able to accomplish anything and he should be institutionalized. However, with his family's encouragement, he is now an author, scholar, opera afficionado, and an important member of Bloomington's diverse community. He represents what can happen when you do not focus on your limitations.

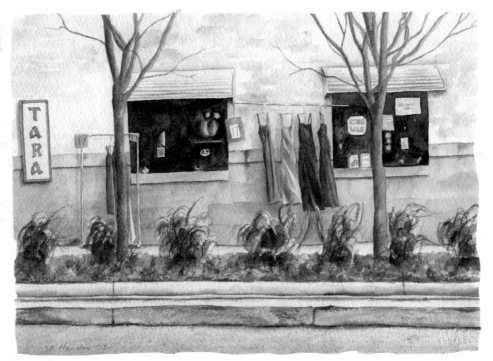

Kirkwood Avenue is home to many interesting shops, including Tara. Merchandise there is often displayed on the sidewalks, which adds flavor and sometimes a little glamour to downtown strolls.

Suzanna Hendrix

The fish atop the courthouse, called Looney Tuna, has been there even longer than the present courthouse, which was built in 1906. The fish weathervane was created by Bloomington blacksmith and community leader Austin Seward sometime in the 19th century.

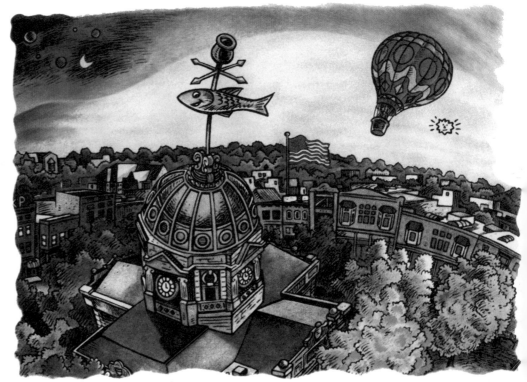

Michael Cagle

The Indoor Holiday Art Fair and Bazaar is an indoor arts and crafts fair held every December at the Bloomington Unitarian Universalist Church.

Jane Jensen

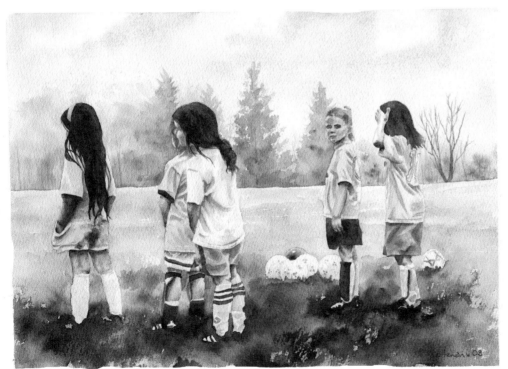

Girls on the sidelines watch and anticipate what will happen next during soccer practice at Karst Farm Park. Youth sports are an important part of the Bloomington community.

Suzanna Hendrix

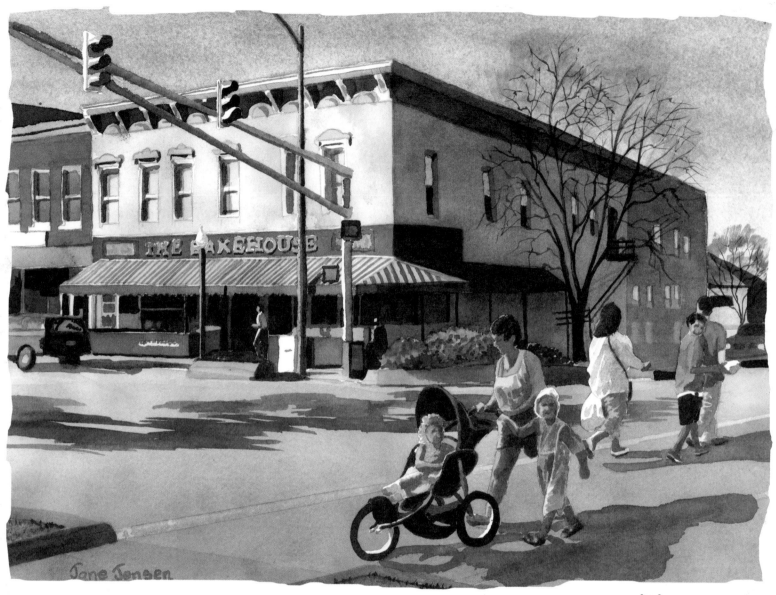

Jane Jensen

The Scholar's Inn Bakehouse, located at 125 North College
Avenue in Bloomington was modeled after European artisanal
bakeries and began its operations in August of 1995.

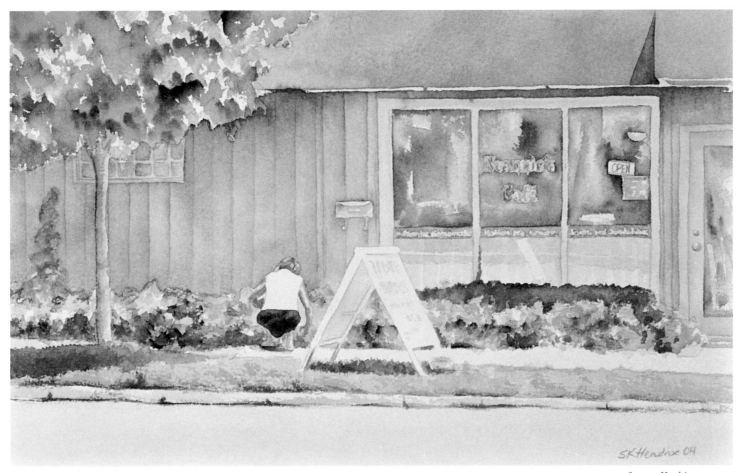

Suzanna Hendrix

*Above, A woman cares for the landscape at a terrific little eatery called Neannie's Café. Neannie's is located just off the Square.*

*At right, The Princess Theatre, which stood at 6th and Walnut, collapsed unexpectedly on June 8, 1985. Fortunately the building was empty at the time.*

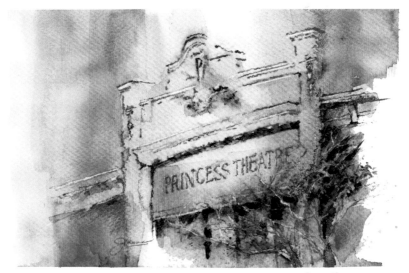

Jeanne Iler

65

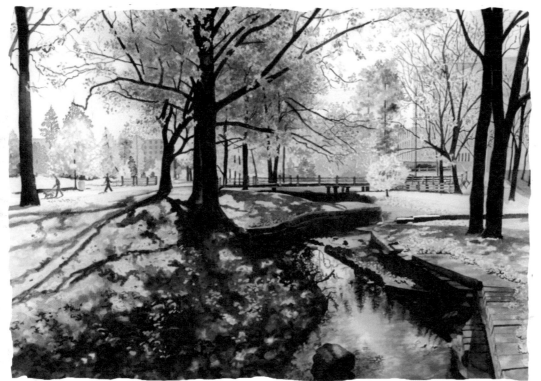

Jane Jensen

This fall scene is located very near the IU president's mansion on campus. You can find it at the eastern end of Seventh street. The passing creek is called River Jordan. This is a famous walkway for the students on campus.

The Sample Gates, located between Franklin Hall and Bryan Hall, serve as a welcoming entryway for students into IU's beautiful 1,860-acre campus. Edson Sample funded construction of the gates in 1987 and dedicated them to his parents, Louise Waite Sample and Kimsey Ownbey Sample Sr.

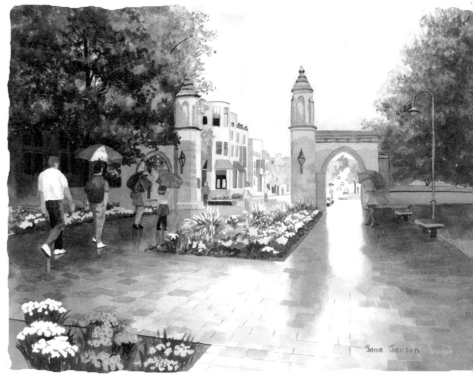

Jane Jensen

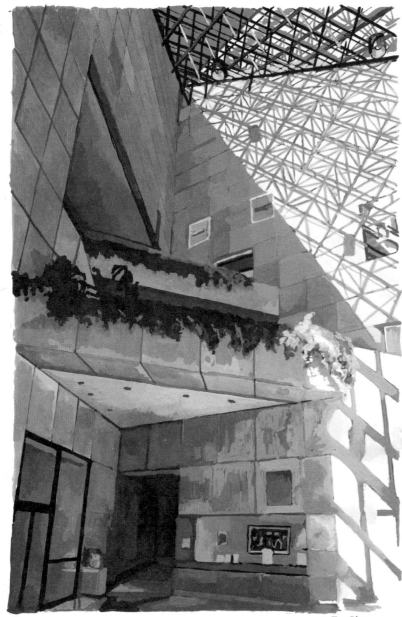

Tom Rhea

Through a skylight webbed with girders, sunlight sends a complex web of shadows down through a large three-story atrium of IU's Art Museum.

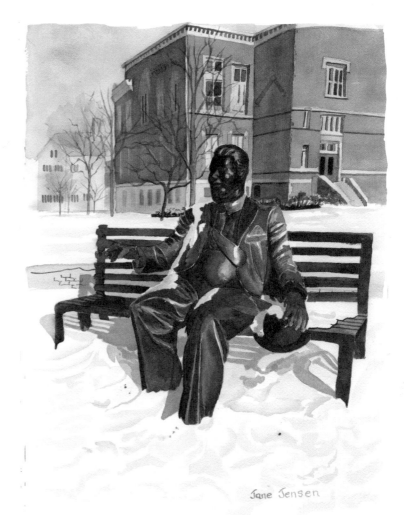

Jane Jensen

A sculpture of the university's eleventh president and first chancellor, Herman B Wells, is located in the Old Crescent area of campus. The statue depicts Dr. Wells resting on a bench ready to greet passersby.

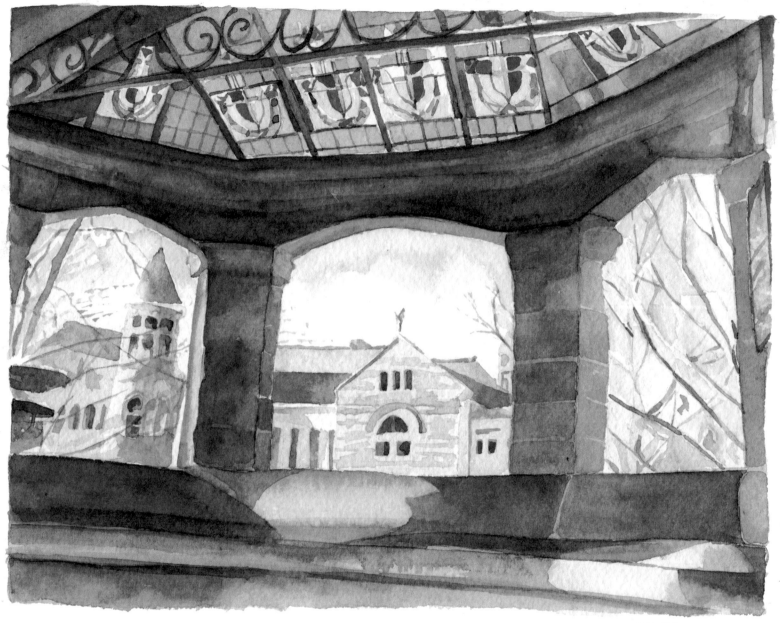

Robin Ripley

The arched windows of the Rose Well House open to a
view of Maxwell in the heart of the campus of Indiana
University.

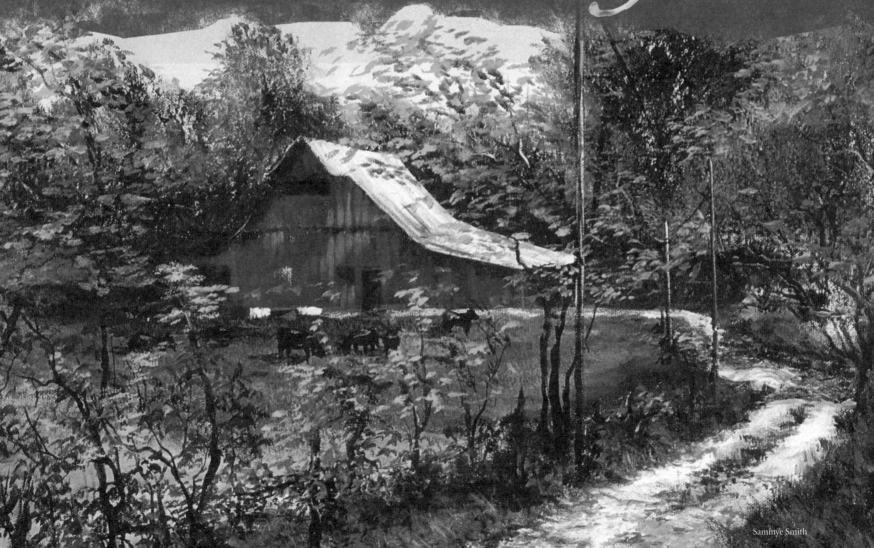

Sammye Smith

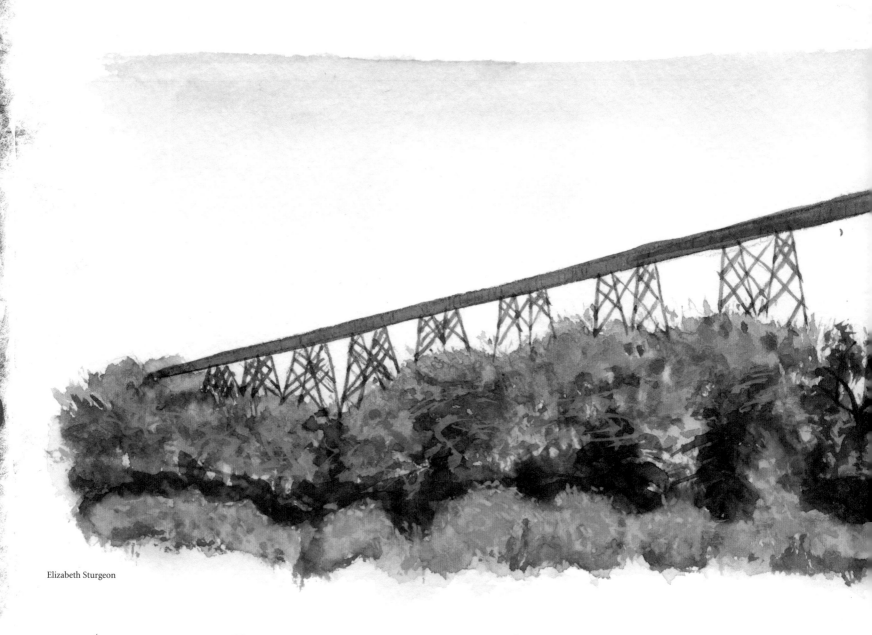

Elizabeth Sturgeon

A short trip from Bloomington lies the town of Solsberry and the
world's third longest train trestle.

Lake Lemon, originally
designed to be a water
source for the city of
Bloomington, is now an
ideal area for many
recreational activities.

Linda Meyer-Wright 71

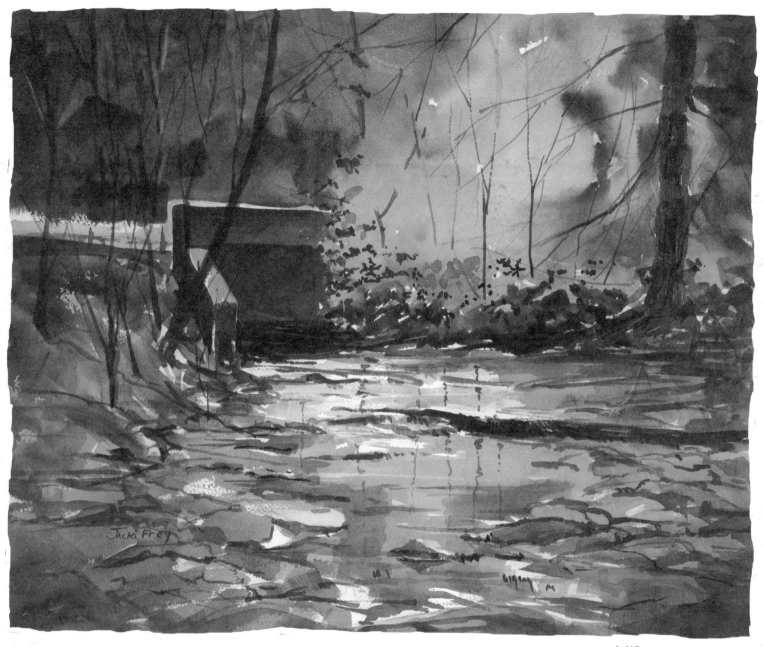

Jacki Frey

A winter sunset on the waters of Cascade Park. Lower Cascade Park was
dedicated in August, 1924 as Bloomington's very first park.

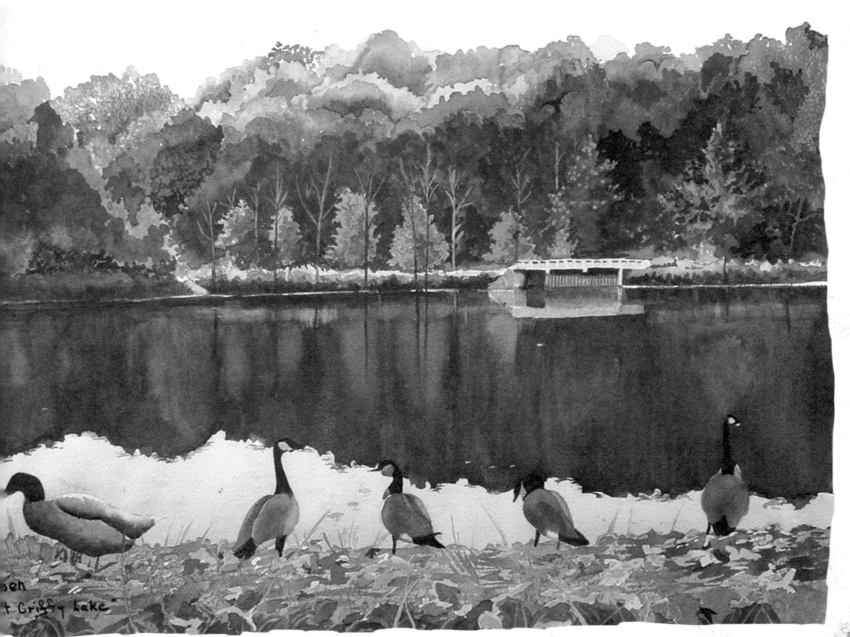

Jane Jensen

This picturesque scene is located on the north side of Bloomington off of Mattlock Lane. Griffy Lake is a great recreational area offering canoeing, and fishing. There are also lovely nature trails to experience.

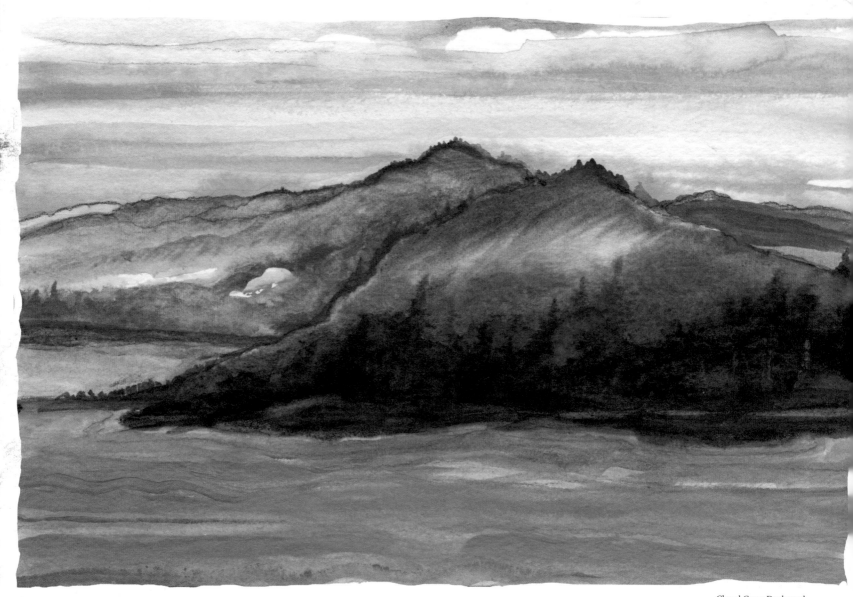

Cheryl Gregg Duckworth

Monroe Lake is nestled in the rolling
hills and woodlands about ten miles
southeast of Bloomington.

74

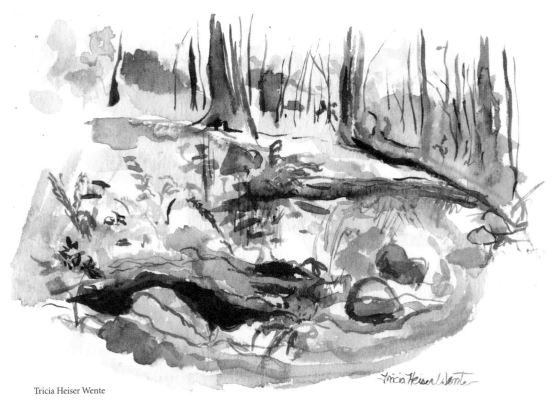

Buckners Cave is a local center of attraction for all area cavers and for many spelunkers from afar.

Tricia Heiser Wente

A trip through the countryside of Monroe County will provide you with many picturesque scenes such as this retired pickup.

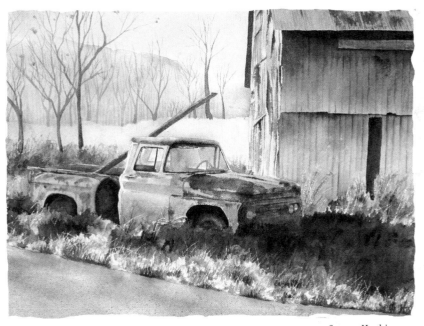

Suzanna Hendrix

75

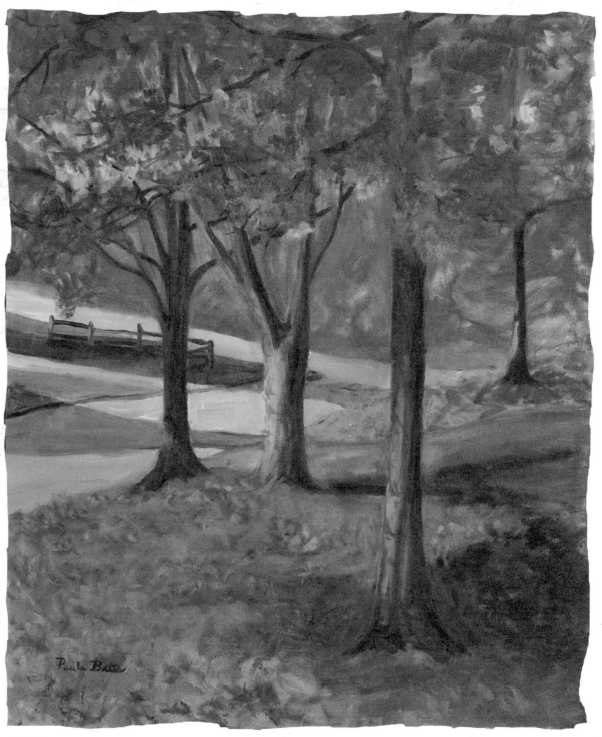

Autumn in Sycamore Knolls, located on Queens Way, High St.

Paula Bates

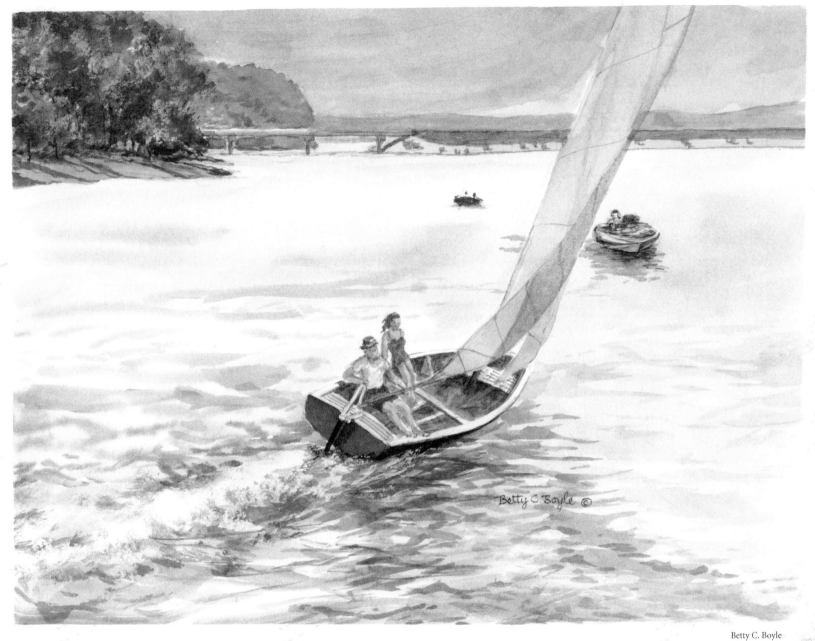

Betty C. Boyle

*Catching the breeze on Monroe Lake, part of Indiana's state park reservoir system, the lake provides endless opportunities for boaters.*

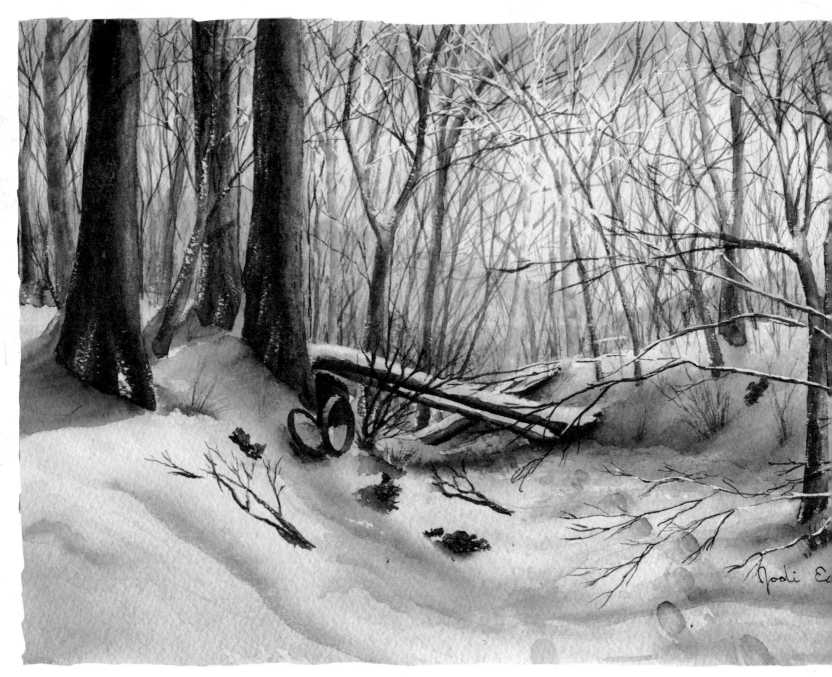

This old wagon road, off of Old 37, is believed to be an old logging road. It's about ten miles nor of town. Because of the amount of rock close to the surface, most of the area was considered inappropriate for farming and was allowed to return to forest. It can still be seen winding through private property and the Morgan Monroe State Forest.

Jodi Estell

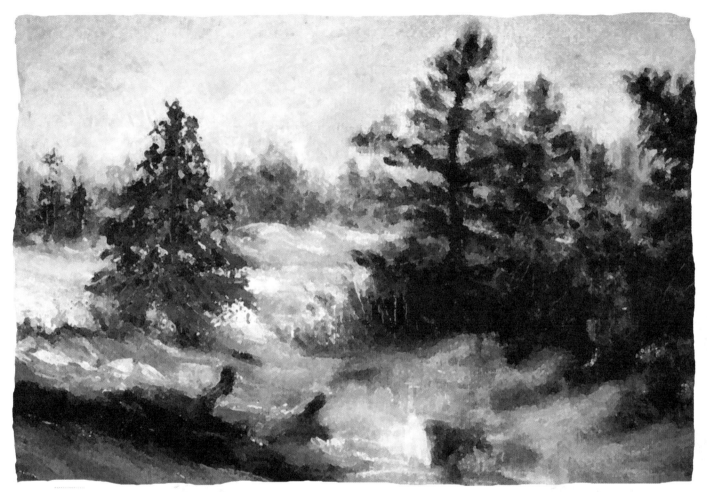

Mary Jo Limp

*A scenic winter view of Smith Rd. East.*

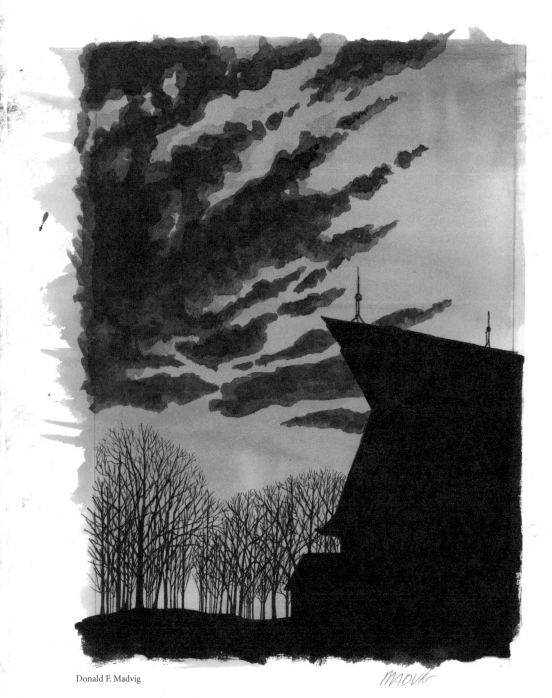

Donald F. Madvig

*Sunset highlighting the silhouette of a barn on 10th Street in Bloomington.*

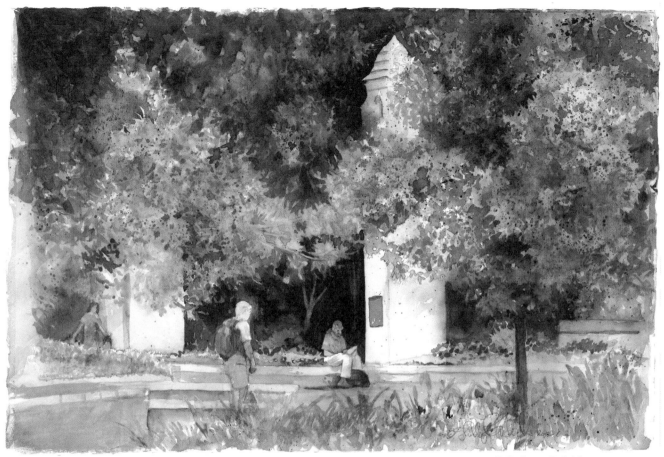

Shelley Cannon Frederick

Monroe County was created by an Act of the Indiana General Assembly in 1818. Bloomington first became a settlement around 1816 when President James Monroe selected the site for a seminary. Whether one believes that Bloomington was named after the glorious blooms of flowers that early settlers observed from a hill overlooking the site, or named after one of its early founders, William Bloom, the richness and vastness of its people and heritage remains true today.

Like Bloomington's early founders, her contemporary leaders are also ardent about the place in which they reside. These community leaders share enthusiasm and dedication to a community whose variety of histories, traditions, and wealth of cultural diversity provides something special for everyone. Whether seeking an art gallery or museum or simply sitting down to a folksy, down-home meal, you'll fit right in. Welcome, come on in!

Indigo Custom Publishing gratefully acknowledges the companies, institutions, and organizations represented here that have willingly and graciously given their steadfast and earnest support to the fruition of the *Bloomington Sketchbook* project.

# Abodes, Inc.

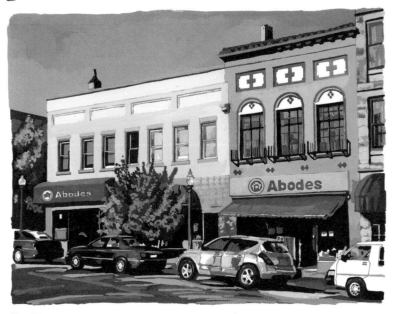

Tom Rhea

Bloomington is an oasis in the Midwest; with a vibrant culture, a major university, and the opportunities and services normally available only in a large metropolitan area, it nevertheless maintains a small-town quality of life and its own special brand of community spirit.

Abodes believes in giving back to the community and represents the frontline that holds Bloomington apart, bringing influences from around the country, infusing an international flair, and creating qualitative environments for people to live their daily lives. Bloomington is more than a place; it is a lifestyle."

—*Mark Lauchli, Principle Corporate Officer*

# Andrews, Harrell, Mann, Carmin & Parker, PC

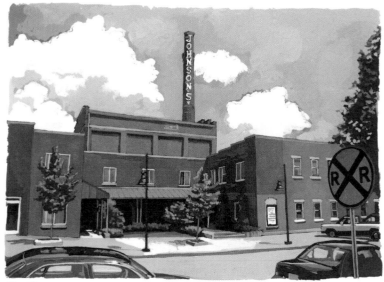

Tom Rhea

As a lifelong Bloomington resident, I have seen our community grow and change in many positive ways. It has become a vibrant, valued center for the arts, business, and education.

At Andrews, Harrell, Mann, Carmin & Parker, we are proud to be a part of Bloomington's rich tradition of quality and service. With more than 150 years of combined legal experience, our firm offers creative solutions and a wide range of legal assistance for businesses, individuals, and families.

It is our goal to contribute to Bloomington's heritage of excellence by continuing our service as one the community's proudest advocates and most active supporters.

—*William H. Andrews, Senior Partner*

# Baxter Pharmaceutical Solutions, LLC

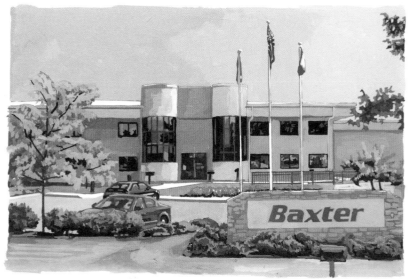

Tom Rhea

Baxter is as committed to serving its business clients as we are to being a good partner within the Bloomington community. We feel fortunate to live and work in such a vibrant community and look forward to expanding Baxter Pharmaceutical Solutions right here in Bloomington!

*—Alisa Wright, Vice President, Business Affairs*

# Greater Bloomington Chamber of Commerce

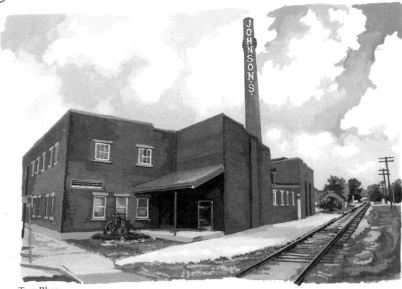

Tom Rhea

A chamber of commerce is all about community development. The board, volunteers, and staff of the one thousand-member Greater Bloomington Chamber of Commerce are proud to join with many other organizations and individuals in continuing to develop Bloomington. Our community's beautiful natural environment, sophisticated workforce, vibrant business sector, top-notch educational resources, committed and engaged citizenry are among the many building blocks we use. We are proud to sponsor this book, especially because it lets local artists show you why Bloomington is a great place to live, work, and play.

*—Steve Howard, President*

# Bloomington Hospital & Healthcare System

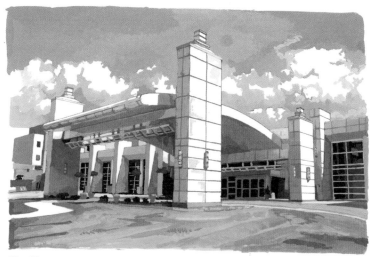

Tom Rhea

In 1905 a red brick house on the outskirts of Bloomington was converted into a ten-bed hospital, and since that time, we have worked diligently to address the healthcare needs of our growing city. Now Bloomington Hospital houses more than 350 beds and employs more than 2,500 caring, compassionate, and talented people. More than just a "happening college town" or a "beautiful retirement community," Bloomington is a place that takes pride in diversity, the arts, higher education, and the overall quality of life for its citizens. We are proud to call Bloomington home and look forward to another one hundred years of keeping our city on the cutting edge of healthcare.

—*Mark E. Moore, President*
*& Chief Executive Officer*

# Building Associates, Inc.

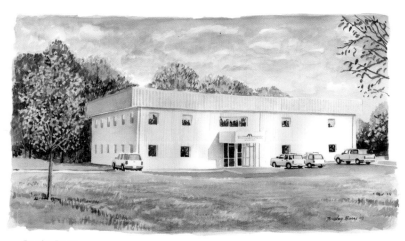

Barclay Burns

Founded in 1983, Building Associates, Inc. is extremely proud to call Bloomington, Indiana, home. We are excited to be celebrating our twentieth anniversary in 2003, and we are especially proud to say that the clients we started with in 1983 are the same clients we still work with two decades later. We pride ourselves on quality workmanship and customer service, and we are grateful that Bloomington has a myriad of quality people in its workforce.

Bloomington is an extremely diversified city, with many activities and opportunities that attract people from all walks of life. One of Bloomington's unique attractions is the fine mix between the liberal-thinking university sector and the conservative-thinking business sector, thus molding a great city and county community in which to live, work, and play.

—*Jack Thompson, President*

# CFC, Inc.

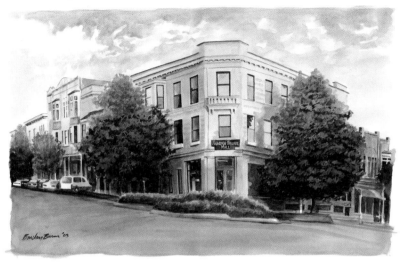

Barclay Burns

Bloomington is situated in south central Indiana and is home to CFC, Inc., a property development and management company that was founded in 1973. Our founders started a trend in Bloomington, Indiana, to restore buildings and revitalize the downtown. CFC, Inc. has become a leader in the restoration and promotion of the downtown area and we are proud to be a part of this unique community.

—*James E. Murphy, President*

# Cook Incorporated

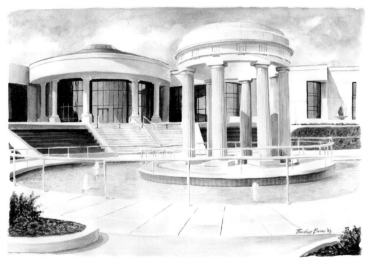

Barclay Burns

Talented, hardworking employees form the backbone of any successful organization, and for four decades, the loyalty, hard work, and ingenuity of the people of Bloomington, Indiana, and its surrounding areas have helped Cook Incorporated grow to become a world-class corporation. Home to Indiana University's beautiful main campus and a state-of-the-art vocational college at Ivy Tech, Bloomington offers cultural attractions and educational opportunities that make it an outstanding place to live, work, and raise a family. For a research-driven, entrepreneurial corporation like Cook, having these strong science, technology, and business education programs close at hand provide a vital resource for our future success, and we're proud to call Bloomington home. I can't think of a better place to grow a medical manufacturing business in Indiana.

—*Kem Hawkins, President and CEO*

# Courtyard by Marriott Bloomington

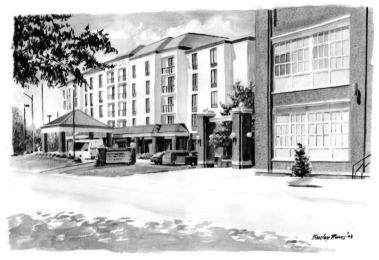

Barclay Burns

Dunn Hospitality Group was searching for a unique community in which to build its flagship hotel back in 1994. Through the efforts of city officials, the Convention/Visitors Bureau, downtown Bloomington, the Bloomington/Monroe County Convention Center, and numerous community leaders, an agreement was formulated to purchase a site adjacent to the convention center, which is now home to Courtyard by Marriott Bloomington.

This hotel has not only become the premier property within Dunn Hospitality Group, but it is now also a top-ranking facility within the Marriott brand. Earning that distinction not only requires the support of the city, but also the commitment of the hard-working, dedicated staff that this community provides.

—*John M. Dunn, President*

# Curry Buick Cadillac Pontiac GMC Truck, Inc.

Patricia Cole

We are celebrating our eighty-eighth year as a Bloomington small business. Our firm is committed to being a leader in giving back to the community, and we have proudly demonstrated that throughout the years.

Being a part of this project is very exciting as we recognize the importance of the arts in enhancing the quality of life in Bloomington. We are committed to our customers and the community.

I am blessed to have eighty-plus caring and dedicated employees.

—*Cary K. Curry, President*

# Employment Plus

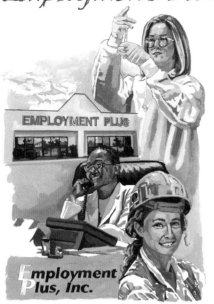

Tom Rhea

It is often easy to take living in a place like Bloomington for granted. During the past ten years in the staffing industry, I have found spoken with many newcomers to our area and have yet to find someone say that they dislike Bloomington. It is especially rewarding to hear people compare where they have come from to our city and share their hopes of making Bloomington their new home.

Employment Plus has been locally owned for more than ten years and employs thousands of employees every year in the Bloomington area. We are proud to be a part of the local economy and look forward to many years of continued growth.

*—Mike Ross, Owner & President*

# Gates Inc., Realtors and Developers

Barclay Burns

Gates Incorporated has been serving the real estate and insurance needs of Bloomington and Monroe County since 1964. We are proud to call Bloomington home. Our community has been blessed with being the home of Indiana University's main campus, as well as many wonderful businesses and industries. We are situated in the beautiful rolling hills of southern Indiana, with world-renowned cultural and recreational activities. Bloomington is a great place to live, work and play.

Gates Incorporated specializes in commercial real estate development and management, as well as providing quality insurance protection for businesses and families throughout the region. We are ready to help design, build, or lease your new facility, or find the proper insurance to cover your business, home or auto. Gates Incorporated is ready to serve you.

*—Jerry W. Gates, President*

# Hoosier Disposal & Recycling

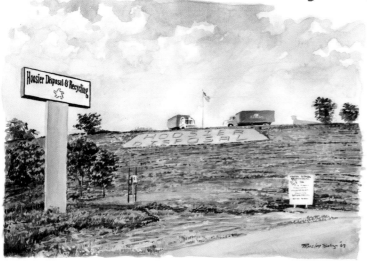

Barclay Burns

Hoosier Disposal is proud to be part of the south central and southern Indiana community. We pride ourselves on providing the most efficient and professional waste collection, disposal, and recycling services in the region. We are striving to be as solid as the area limestone and basketball traditions that have made this part of Indiana so unique.

*—Jeff Wilson, General Manager*

# ISU The May Agency

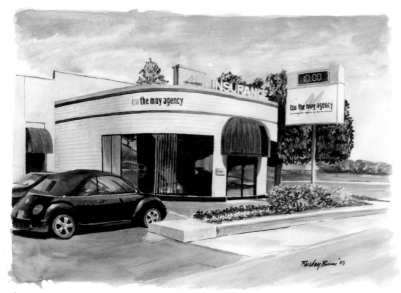

Barclay Burns

Bloomington, Indiana represents the best of both worlds; we have the charm of a small town and the entertainment opportunities of a large city. The presence of Indiana University creates a diverse community that contributes to the variety of shops and restaurants in Bloomington, as well as the large number of festivals and seasonal events.

I have noticed over the years that often the places that I am attracted to while on vacation are towns that remind me of Bloomington. There aren't many small cities that have all the attributes of Bloomington, and when you find a city like Bloomington, you can feel that it is something special.

*—Paul May, President*

# Ivy Tech State College

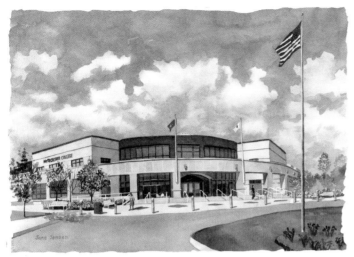

Jane Jenson

Bloomington lies in South Central Indiana in the heart of the Crossroads of America! Its natural outdoor beauty and the local business and educational environment makes Bloomington an ideal place to work, live, and play! Exciting changes are constantly occurring in our community, and Ivy Tech State College-Bloomington is having a major impact on the economic development and continued success of this region. Because our graduates want to stay and work in this area after graduation, it is our mission to be a College for our Communities! At Ivy Tech, we strive to meet the technical, professional, and educational needs of both the individual and the corporate community by creating and sustaining strategic partnerships. We are proud of the success of our students and are proud we are making a difference here in Bloomington!

—*John R. Whikehart, Chancellor*

# Monroe County YMCA

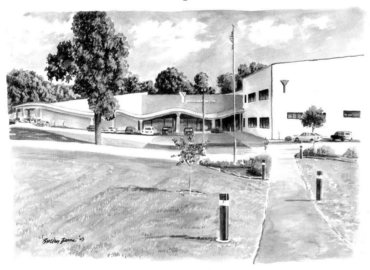

Barclay Burns

The city of Bloomington has supported the Monroe County YMCA and its mission for more than one hundred years. The community embraced our focus on cardiovascular fitness education and the building of this beautiful facility to provide programs for people of all ages. We are fortunate to live in a city that is so socially and culturally diverse. The YMCA has been given the unique opportunity of bringing this diverse community together through programs that build healthy spirit, mind and body for all.

Bloomington is experiencing an exciting time of change and growth. The YMCA is proud to be a part of it.

—*Roberta Kelzer, Executive Director*

# PTS Electronics

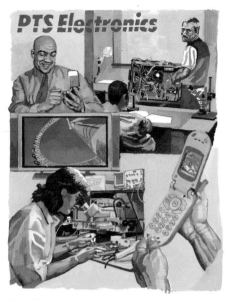

Tom Rhea

PTS Electronics is proud to call Bloomington home. Through a unique partnership between business, higher education and local government, Bloomington is truly one of the great small cities of America. From our vibrant downtown and beauty of Indiana University, to the surrounding wooded rolling hills of Monroe County, Bloomington is a special place to both live and work.

As a major employer in Bloomington, PTS has benefited from Bloomington's great resources and people and has emerged as the nation's largest service firm for wireless communication and telecommunication products. Our commitment to high ethical and moral standards originated from the attitudes found throughout the Bloomington community.

*—Jeff Hamilton, President*

# Southern Indiana Pediatrics

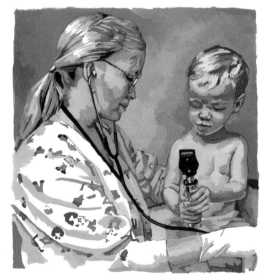

Tom Rhea

Bloomington has the best elements of small-town charm and big-city opportunity. From a vital downtown square, we are steps away from the pastoral hills of southern Indiana. From the heart of the university, we are minutes away from a strong industrial and business base. It is a city of contrasts, and that diversity has been our strength. The overall feeling of Bloomington is an attraction for an outstanding medical community that adds to the quality of our lives. Southern Indiana Pediatrics is proud to be a part of what makes Bloomington a great place for families.

*—James J. Laughlin, MD, President*

# Tabor/Bruce/Puzzello & Associates, Inc.

Tom Rhea

Monroe County and Bloomington Indiana are the type of places that we all seek to call home. Our city carries forth many traditions of the past to strengthen the future. Situated in hilly southern Indiana, Bloomington is blessed to be surrounded by lakes, many parks, and a vibrant active downtown.

Tabor/Bruce/Puzzello Architects is proud to be a design leader of many important local structures for more than thirty years. Our partners are both involved in many local organizations and participate alongside other business leaders to ensure the continued quality of life in Monroe County. Bloomington and Monroe County are home for us who live here, as well as those who visit time and time again.

*—Doug Bruce, President*

**Paula Bates**
812-336-4236 • 2201 Queens Way
Bloomington, IN 47401
pj_bates@hotmail.com
www.paulabates.com
www.gallery-north.org
Page 76

**Betty C. Boyle**
317-252-5652 • Grandview Lake Studio
6260 Avalon Lane E. Drive
Indianapolis, IN 46220
www.bcboyle.com
bcboyle2@comcast.net
Pages 7, 77

**Connie Brorson**
812-333-6658 • 403 S. Madison St.
Bloomington, IN 47403
candcbrorson@aol.com
Page 52

**Michael Cagle**
812-332-4647 • 205 N. Walnut St. #100
Bloomington, IN 47404 • cagleart@kiva.net
Page 62

**Cheryl Duckworth**
812-334-8421 • 7807 Lampkins Ridge Rd.
Bloomington, IN 47401
Dgrdnart@aol.com
Page 74

**Jodi Estell**
812-323-9617 • 940 E. Chambers Pike
Bloomington, IN 47408
jestell@hotmail.com
Pages 37, 44, 57, 78

**Shelley Frederick**
812-988-1819 • 8463 Garrity Rd.
Freetown, IN 47325
shell@shelleyfrederick.com
www.shelleyfrederick.com
Pages 35, 38, 48, 81

**Jackie Frey**
812-333-4728 • 355 S. Madison Street
Bloomington, IN 47403
jfrey@bloomington.in.us
Page 72

**Jeanne Iler**
812-876-8610 • 3825 N. Collins Dr.
Bloomington, IN 47404 • miler44383@aol.com
Pages 44, 52, 65

**Jane Jenson**
812-339-7665
3417 Stoneycrest Rd.
Bloomington, IN 47404
pjenson@bluemarble.net
Cover, Pages 23, 30, 33, 34, 36, 39,
41, 43, 46, 51, 63, 64, 66, 67, 73

**Tim Kennedy**
812-330-8095
1000 S. Lincoln Street
Bloomington, IN 47401
tkennedy@indiana.edu
Pages 37, 45, 49, 50, 51

**Cathy Korinek**
812-339-6168
5465 E. James Road
Bloomington, IN 47408
catkorinek@aol.com
Page 32

**Mary Jo Limp**
812-988-1948 • 1436 State Rd. 46 W.
Nashville, IN 47448
Page 79

**Donald F. Madvig**
812-339-6567
Sleeping Dogs Studio • 1006 Carleton Ct.
Bloomington, IN 47401
dmadvig@insightbb.com
sleepingdogs.home.insightbb.com
Pages 31, 42, 54, 80

**Drummond Mansfield**
Contact Indigo Custom Publishing, 478-471-9578
Pages 20, 47

**Judy Noyes-Farnsworth**
812-336-1184
2880 E. Bethel Lane
Bloomington, IN 47408
noyesfar@bloomington.in.us
Pages 38, 56

**Suzanna Hendrix**
812-876-0408 • 5795 West Maple Grove Rd.
Elletsville, IN 47429
skhendrix@hotmail.com • www.hendrixwatercolors.com
Pages 13, 14, 26, 29, 38, 55, 58, 59, 61, 62, 63, 65, 75

**Tom Rhea**
812-336-8335
1019 East Wylie Street
Bloomington, IN 47401
tomrhea@kiva.net
www.tomrhea.com
Pages 8, 19, 31, 33, 37, 39, 40, 67

**Robin Ripley**
812-332-6243 • 1800 E. Arden Dr.
Bloomington, IN 47401 • rripley@kiva.net
Pages 17, 20, 24, 27, 32, 36, 55, 68

**Bridgette Z. Savage**
812-825-5884 • Buckbeech Studios, P.O. Box 430
Sanford, IN 47463 • buckbeech@smithville.net
www.bloomington.in.us/~artspace
Page 20

**Sammye Smith**
812-825-5928
7131 Cavewood Ct.
Bloomington, IN 47403
sydina@insightbb.com
Pages 29, 42, 49, 59, 69

**Elizabeth Sturgeon**
812-825-7543
RR#4 Box 648
Bloomfield, IN 47424
esturgeon@msn.com
Pages 25, 56, 60, 70

**Tricia Heiser Wente**
812-824-9578
2772 Plateau Place
Bloomington, IN 47401
tricia@wente.com
www.wente.com
Pages 53, 60, 75

**Linda Meyer Wright**
812-597-5974
7565 Fern Hil Lane
Morgantown, IN 46160
linda@wrightathomestudio.com
www.wrightathomestudio.com
Page 71

# Index

# Index